Ladies on the Lot

Ladies on the Lot

Women, Car Sales, and the Pursuit of the American Dream

Helene M. Lawson

ROWMAN & LITTLEFIELD PUBLISHERS, INC.
Lanham • Boulder • New York • Oxford

ROWMAN & LITTLEFIELD PUBLISHERS, INC.

Published in the United States of America
by Rowman & Littlefield Publishers, Inc.
4720 Boston Way, Lanham, Maryland 20706
http://www.rowmanlittlefield.com

12 Hid's Copse Road
Cumnor Hill, Oxford OX2 9JJ, England

British Library Cataloguing in Publication Information Available

Library of Congress Cataloging-in-Publication Data

Lawson, Helene M.
 Ladies on the lot : women, car sales, and the pursuit of the American dream / Helene
 M. Lawson.
 p. cm.
 Includes bibliographical references and index.
 ISBN 0-8476-9862-9 (alk. paper) – ISBN 0-8476-9863-7 (paper : alk. paper)
 1. Women sales personnel. 2. Selling—Automobiles. I. Title.

HF5439.5 .L39 2000
658.85—dc21 99-057385

Printed in the United States of America

♾™ The paper used in this publication meets the minimum requirements of American
National Standard for Information Sciences—Permanence of Paper for Printed Library
Materials, ANSI Z39.48-1992.

CONTENTS

ACKNOWLEDGMENTS

This research began as a dissertation project under the tireless ongoing support of Loyola University of Chicago sociology faculty. Judith Wittner helped me discover the joy of women's studies and ethnography. Helena Lopata drew my interest to the study of work and occupations and made me feel what I had to offer was valuable, eventually including my work in her series, *Current Research on Occupations and Professions*. Phillip Nyden gave me encouragement as well as my first opportunity to do in-depth interviewing. I am grateful to the University of Pittsburgh at Bradford for their financial support in helping me continue this study through paper presentations at conferences and Charles E. Babbitt and Richard E. Wright for deeming my initial work worthy of publishing in the Pennsylvania Sociological Society Journal, *Sociological Viewpoints*, thereby encouraging me to continue. My heartfelt appreciation goes to E. Doyle McCarthy, my daughter, Elyce, my son, Reid, and my husband, Larry, for continuing to believe in my work when I did not. Special thanks go to Julie Carr, whom I met in the hospital when I fractured my arm at a time when I was trying to meet a publication deadline for an article on hair for *Qualitative Sociology*. Julie offered to type my work then and was willing to put this manuscript into camera-ready form. I also wish to thank Jill Rothenberg, my original editor at Rowman and Littlefield, for her encouragement and help but especially for her appreciation of ethnography. Thanks also to Dean Birkenkamp, Sociology/Education Editor; Christine Gatliffe, Editorial Assistant; Karen Johnson, Assistant Production Editor; and Hallie Gladden, in-house Designer for helping to bring this book to print. Finally, special thanks go to the men and women car sales representatives who shared their stories with me and whose names I cannot share with the readers.

PREFACE

In December 1986, a short time before Christmas, I was on my way to teach a night course at Elmhurst College, a private four-year liberal arts school situated in a Chicago suburb a great distance from where I lived. Traffic was heavy on the tollway that evening. I was stopped behind a row of cars on an off ramp when I was rear-ended by a drunken driver and my car was demolished. For three weeks in the dead of winter, I searched for a replacement. I ended up buying a used car, the same make and model of a car I once owned and had vowed never to own again.The sales agent who convinced my husband and me to buy this car was a young woman who told me about herself as we negotiated the sale. I was impressed by her altruistic background and therefore presumed she must be honest. She was educated as a social worker and had previously counseled recovering alcoholics and disturbed youth. I was amazed by her ability to run around the icy car lot, pulling out cars for us to test drive, wearing high heels. She fascinated me. Why would anyone with a career as a social worker want to sell cars?

I had just completed research on impoverished unemployed women looking for work. None of these women ever mentioned the possibility of selling cars, and I would never have thought to suggest this occupation to women seeking jobs. I wondered what led women to this unusual field so notorious for its dishonesty. How did they get hired? Were they successful? I was surprised to find that there was no sociological literature on women who sold cars. There were, however, occasional articles in newspapers about pioneer women sales agents working the auto show, or dealers wishing to hire women to sell to women.

I wondered how women got along in an agency dominated by men and if women's sales techniques differed from those of men. I liked the woman who sold us our car. Even though it was not the car we set out to buy, it was a good car. Our sales agent was easy to be with and did not pressure us. She talked about her personal life with us. She was a good listener and helpful. Yet, I did not fully trust her. Some of the things she said were not true. The stripped down, less expensive cars she said were coming in the following weekend never arrived. Many of the questions I asked her went unanswered. In the car we purchased, a plastic part was missing from the transmission control leaving a hole in the floor covering. She told me it was "supposed to be that way." My husband disagreed and asked to see the manager, who offered to replace the part.

She avoided the whole issue of the missing part, claiming innocence. But, she was patient and gentle. I assumed this was because of her social work background. I wondered if other women sales agents were like her. Was this a gender phenomenon, or just a matter of differences among people? Usually people dread the car sales encounter. Could my pleasant experience be due to our agent's motherly qualities or her sisterly warmth? Were women more sensitive and honest members of the sales profession? Were they better or different at men's work? Here was a way I could understand more about this phenomenon. The social interactions surrounding car sales seemed a wonderful laboratory for research on the impact of gender differences and behavior in the workplace.

Therefore, my research problem was to understand how women accomplished careers in high commission car sales. I wished to uncover the issues specific to this nontraditional work: to answer questions about what attracted women to this occupation, how they entered the field, and the obstacles they faced as outsiders and newcomers. I wanted to describe the careers of women in auto sales from their own accounts, focusing on their "moving perspective," on the "typical sequences of position, achievement, responsibility, and even of adventure" that they found and created as they pursued their new and different occupations (Hughes 1971:137). I was especially interested in how they were trained to master the specialized knowledge required for the kinds of selling men accomplished.

When I posed this question to my first interviewee, she showed me a brochure listing educational seminars put out by the Greater New York Automobile Dealers Association. I decided to contact the coordinator of these seminars, Steven Shapiro. At this time (the late 1980s), the automobile industry was interested in women as wives or girlfriends who influenced the buying decisions of men. They did not see them as potential car sales agents. Car sales forces were composed of approximately 3 percent women. Mr. Shapiro, however, was a progressive thinker. He was interested in any information I could share about the needs of women sales agents because he was organizing new training sessions for dealers and wanted to include sessions specifically geared to women employees: how to attract them, what training women wanted, and how to make dealerships more "woman friendly." We spoke on several occasions over the next few years about changes in the industry, and I realized that in order to see how this regendering of car sales worked out, I would have to do a longitudinal study, extending my research over some period of time. Although I published two journal articles on the subject, one in 1994 and another in 1995, I never lost interest in women and car sales. Everytime someone I knew bought a car, I would question them about their experiences. Colleagues never seemed to tire of my research topic either, because newspaper articles about automobiles and dealerships kept popping up on my desk or in my mailbox.

This book covers more than ten years of interviews in an effort to understand where women are going in terms of nontraditional jobs as we enter a new millennium. It speaks to issues of gender and class in a series of verbal snapshots depicting the struggles of women as they navigate an abusive, hostile envi-

ronment dominated by men. Although it offers no amazing discoveries, the book is filled with funny, sad, interesting, and enlightening pictures of one small way women are currently trying to pursue the American Dream.[1]

Note

1. Most literature on inequality, social class, and upward mobility discusses the pursuit of the American Dream. Diana Kendall, *Sociology in Our Times* (Belmont, Calif.: Wadsworth Publishing Company, 1999) defines "The American Dream" as "the belief that each subsequent generation will be able to acquire more material possessions and wealth than people in the preceding generations. To some people, achieving the American Dream means having a secure job, owning a home, and providing a good education for their children. To others, it is the promise that anyone may rise from poverty to wealth if he or she works hard enough" (1999:198). In the 1950s, the dream generally included a wage-earner husband with a homemaker wife. They resided in a home with a two-car garage in a suburban area, took vacations, and were concerned with social position and the ability to keep up with the neighbors. In the 1980s and 1990s, the American Dream included "superwomen" who pursued careers while caring for families as well as single independent woman with prestigious careers.

INTRODUCTION

I like nice things. Living on your own with two kids takes money. I worked as a waitress for awhile, but I hated the work, the hours and the pay. I needed a new car, and I went to this Saturn dealer, and they talked me into working here. So here I am. I've been here six months and it's hard, I'm not selling enough right now, but I'm hoping it [the money] gets better.

−Sonja, *28-year-old single mother*
(1999 interview)

The first thing colleagues and friends wanted to know when they heard I was researching women in car sales was: "Who can give me a good deal?" They expected me to tell them the name of a woman who would sell them a car for less money than they would pay elsewhere. One young student even asked me if he should specifically look for a woman sales agent because he had heard they were "more honest." I thought that was funny. As previously discussed, I did not get a particularly good deal when I bought my own cars. This is leading up to the fact that reading this book will not get you a "good deal." What you will learn is what car sales is currently like for people like Sonja and how conditions for women have or have not changed over the years from 1988 to 1999.

Actually, some interesting changes have taken place in car sales that seem encouraging for women. For example, "one-price" dealerships that promise "no-haggle, no-pressure softer sales" have emerged. Saturn is one type of car that is sold this way and women customers seem to enjoy it. For example, Maureen, a proud Saturn owner, volunteered this information:

They let you alone to kind of look around and I asked a couple questions to the receptionist. I took my husband but the sales-woman didn't pressure us and she talked to me. The only things she told us about and that I think I paid too much money for were the sunroof, fancy floor mats and console in the middle. It was my credit info she took down. In fact, the loan is in my name. That's the first time that's ever been done for me before.

This woman sales agent probably made good money on the extras she talked Maureen into buying. But Maureen says she did not feel pressured. Maybe that is why Saturn likes using women as role models for its "softer" sales force. Or,

1

maybe they like women because they work for straight salary and less commission. Either way, Saturn set a record by hiring a sales force composed of 19 percent women (Spear 1999). Sonja is one of these women. She, like the other women in my book, has a positive vocabulary about money, longs to win, and has imagination and dreams. Sonja is not being paid a high salary, her commissions from sales of extras are poor, and she is not doing as well as she had hoped. But she is determined to continue, to take advantage of her new opportunity. And Saturn is continuing to offer opportunity to women as evidenced by its newest CEO. In 1999, General Motors Saturn Division hired Cynthia Trudell, wife and mother of two teenagers, as the "company's new chairman [sic] and president" (Martin 1999:125).

However, most dealerships have not added many women over the years. The larger one-priced dealerships I visited had few to no women selling. Only 8 percent of the total United States population of car sales agents are women, and 26 percent of automobile dealerships have no women on the floor. A majority of the 74 percent of agencies with women sales agents claim to have only one (Spear 1999).

Although there has been a small rise in the number of women in car sales over the past ten years (from approximately 5 percent to approximately 8 percent) (Spear 1999), it is still hard for women to break into the occupation. The car has a long history as a masculine icon that was "born in a masculine manger, and when women [seek] to claim its power, they [invade] a male domain" (Scharff 1991:13).[1] We need only to recall television shows of the past, such as *Knight Rider*, the portrayal of a hero and his intimate relationship with a talking car, the *Dukes of Hazard*, a show where men are dependent on cars for fun and excitement, or more current action adventure movies such as *Viper*, to see the relationship between men and cars leaves little room for women. For young men, cars have been and still are symbols of coming of age, marking a boy's passage into the world of men (Scharff 1991). Perhaps this is why sexual harassment of women is still widespread at most dealerships, and women sales agents voice their complaints about this throughout the book. For example, after thirteen years in the office, Pearl was given a chance to sell. She quit six months later, after a particularly distressing incident:

> So they invited me to a sales meeting ... first time ever! And I
> felt like I had really made it. I go to this back room and all the
> guys are sitting around laughing. The local prostitute is up on
> the table doing a strip, shaking her ass, and they're looking at
> me for my reaction.

Women like Pearl have grit and determination. But, they also need armor to deal with co-workers', employers', and customers' constant harassment. Many women learn to "toughen up" or distance themselves. They say that harassment either lessens or becomes easier for them to ignore when there are more women working the floor. Yet, women agents do not always work as a team, giving each other emotional support. Although most say they are pleased when

other women work at their agencies, women agents are critical of the demeanor and behavior of other women. They complain that "saleswomen with loose morals sleep with customers, dress like whores and give other women in car sales a bad name." None of this has changed much over the years.

Other problems specific to the structure and culture of car sales involve instability, pressure to sell, and aggressive sales methods at most dealerships.[2] This too has not changed. Even though workers have to put in a lot of hours, most sales agents do not make enough sales, so they get fired or move to other dealerships where they hope their situation will improve. Eight years ago there was one woman sales agent in the Bradford area. She got fired and went searching for a new dealership. Since then, two women were hired at local agencies and both eventually quit the business. Currently there are no women sales agents in the area. Women in this book complain about this instability, but do not discuss trying to change the extremely competitive system that causes it. They do not demand structural change on a large scale. They do not have enough power. Sometimes they make change on a small scale, such as having their dealership set aside a play area for children. However, if women confront the men too often, they get fired. Even Helen, a respondent who owns two dealerships, has taken up the men's model in order to fit in with the community of dealerships, owned and operated by men. She too, advises the women who work for her to "not take the guys so seriously, they're just kidding ... you need to learn to get along with them." Instead, most women look for personal individualistic solutions: ways to change themselves. These ways involve making peace with compromise, capitalism, and men.

Women agents compromise by taking up behaviors they may not like or have not used before. They adopt a code of anti-ethics. They "hide their beliefs and violate their own ethics every day just to survive" (Wolf 1993:75). For example, I witnessed a woman agent laugh and agree with a group of men arguing that women who complain are "on the rag" or "not getting enough." I also observed women agents change over time and learn to lie and "hustle" in order to make money with their mouths. To get along with men customers and co-workers and fend off unwanted advancements or lewd comments, women need to learn "street smarts" and to "think on their feet." Some women may have come into the occupation with these skills. Others learn them under fire. Some of the women who succeed on these terms set by men are eventually accepted into their exclusive club. In spite of all this, many women are sad that they are not selling on their own terms. Some try to set different examples for men to model. For example, they spend time with "tire kickers" (people just looking and not ready to buy). But many of these women do not succeed in car sales. They know that in other sales situations, such as Mary Kay Cosmetics and real estate, there are more women selling and it is easier, so some women change occupations.[3]

What, then is the significance of my ten-year study for women like Sonja, women who work in other nontraditional jobs and women in the future workforce? The research adds new information about what this type of work is like, how it has changed, and how workers deal with it. This information can be

shared and discussed. Dialogues about coping strategies and ideas for change can be compared. We can begin to comprehend what these workers have in common with other workers and perhaps get beyond personal situations to understand structural issues. The evidence that women can be successful at nontraditional work and can get into positions of power in areas dominated by men is encouraging. Current findings show that women are learning to succeed through compromise rather than change. But the unraveling of gender lines is an ongoing process and the balance, areas, and extent of compromise may change. Perhaps change has already occurred because of women's presence and their willingness to work for straight salary and smaller commissions at specific dealerships. These occurrences may eventually reduce commission for all car sales agents. In the past when women have entered male occupations in large numbers, men have left and earnings have lessened.[4]

Many of these questions can only be answered in the future. In the meantime, I hope you find the following account as enlightening as I have. It is by necessity limited to my sample. I do not generalize to different parts of the country and I have left, for the most part, the job of uncovering black and other minority women's important experiences to other researchers more knowledgeable in those areas.

Notes

1. On the history of the automobile, see Clay McShane, *Down the Asphalt Path: The Automobile and the American City* (New York: Columbia University Press, 1994); J. J. Flink, *The Car Culture* (Cambridge, Mass.: MIT Press, 1975); J. Rae, *The American Automobile: A Brief History* (Chicago: University of Chicago Press, 1965); Virginia Scharff, *Taking the Wheel: Women and the Coming of the Motor Age* (Albuquerque: University of New Mexico Press, 1991) and Charles S. Rolls, "Motor Vehicles, Light," in *Encyclopedia Britannica* (New York: Encyclopedia Britannica Co, 1911).

Men controlled the automobile. They were resistant to women as drivers, and they would not hire women to sell cars because men would not buy cars from women who they felt were ignorant about cars or how to sell them. Although the art of persuasion and the skills of selling were important resources to the department store clerk, women were still not deemed capable of or interested in mastering the specialized technical knowledge supposedly required for more aggressive kinds of commission selling accomplished by car sales agents. For a discussion on stationary and mobile sales, see Helena Lopata, Cheryl Miller, and Debra Barnewolt, *City Women in America* (New York: Praeger, 1986 137-151). For a more complete history of sales, see Penrose Scull, *From Peddlers to Merchant Princes: A History of Selling in America* (Chicago: Follett Publishing Company, 1967).

For history on the gendered division of labor see Harriet Bradley, *Men's Work, Women's Work* (Minneapolis: University of Minnesota Press, 1989); Shirley Dex, *The Sexual Division of Work: Conceptual Revolutions in the Social Sciences* (New York: St. Martin's Press, 1985); and Barbara Reskin and Irene Padavic. *Women and Men at Work* (Thousand Oaks: Pine Forge Press, 1994). For human capital, social structural, and feminist theories on the rationale for dividing labor along gendered lines, see Harry Braverman, *Labor and Monopoly Capital* (New York: Monthly Review Press, 1974);

Richard Edwards, *Contested Terrain: The Transformation of the Workplace in the Twentieth Century* (New York: Basic Books, 1979); and Cynthia Fuchs Epstein, *Deception Distinctions: Sex, Gender and the Social Order* (New Haven: Yale University Press, 1988).

2. Aside from the ability to understand how cars worked, selling cars posed problems different form those of selling other kinds of consumer goods. Automobiles were not sold for sticker price and customers were expected to make deals with sales agents whom in turn had to satisfy management. To encourage sales agents to develop "haggling" strategies that were lucrative for the agency, singular concern for economic success was made an approved legitimate objective or goal. Sales agents made choices on behalf of their organizations that were influenced by the rewards and punishments they received. Thus, sales agents were motivated to lie and cheat in order to make a profit and establish a career. For a history of bargaining methods used in sales, see Joy Browne, *The Used Car Game: A Sociology of the Bargain* (Lexington, Mass.: Lexington Books, 1973). To understand how and why corporations encourage workers to use illegal activities, see Diane Vaughan, *Controlling Unlawful Organizational Behavior: Social Structure and Corporate Misconduct* (Chicago: University of Chicago Press, 1983); Gilbert Geis and Robert Meier eds., *White Collar Crime* (New York: Free Press, 1995); and Harvey Farberman, "A Criminogenic Market Structure: The Automobile Industry," *Sociological Quarterly* XVI: (1975) 438-457.

3. See Barbara Thomas and Barbara Reskin, "A Woman's Place Is Selling Homes: Occupational Change and the Feminization of Real Estate Sales," in Barbara Reskin and Patricia Roos, eds., *Job Queues, Gender Queues: Explaining Women's Inroads Into Male Occupations* (Philadelphia: Temple University Press, 1990), 205-223; Barbara Thomas. "Women's Gains in Insurance Sales: Increased Supply, Uncertain Demand," in Reskin and Roos, eds., *Job Queues, Gender Queues,* pp. 183-204, (Philadelphia: Temple University Press, 1990); and Polly A. Phipps. "Occupational Resegregation among Insurance Adjusters and Examiners," *in* Reskin and Roos, eds., *Job Queues, Gender Queues,* pp 225-240, (Philadelphia: Temple University Press, 1990). Also of interest is Dorothy Pevin, "The Use of Religious Revival Techniques to Indoctrinate Personnel: The Home-Party Sales Organizations," *Sociological Quarterly* (1968) 9:97-106. For a more recent example of this literature, see Maureen Connelly and Patricia Rhoton, "Women in Direct Sales," in A. Statham, E. M. Miller, and H. O. Mauksch, eds., *The Worth of Women's Work* (New York State University of New York Press, 1988), 245-264.

4. See Michael J. Carter and Susan Boslego Carter, "Women's Recent Progress in the Professions or, Women Get a Ticket to Ride After the Gravy Train Has Left the Station," *Feminist Studies* (1981): (7) 476-504.

PART ONE

BEHIND THE SCENES

1

EN ROUTE TO SELLING

I don't want to do manual labor and come home dirty. I don't want a career where you work for a company for years and try to climb a corporate ladder either. Here I can "hang out," and if I "hit a good lick," I can make quite a bit of money real quick.

—Jim, *24-year-old sales agent*

A gentleman came in where I worked [a restaurant and bar]. And he gets drunk and he is telling me all about the car business. He said he was a manager and he gave me his card. I thought, "What the heck. This could solve my financial problems." So I called him the next day and I said, "This is Yolanda and I'm accepting your offer to come over and talk about me getting a job there." And he said, "Yolanda who?" But I went in there anyway and I kind of pushed him and they finally hired me. But my sales are not so good and I'm taking a lot of harassment.

—Yolanda, *ex-part-time bartender*

Both men and women said they entered car sales "for the money." The majority of men chose to work in car sales early on in their careers. Frank liked being around cars because his father had once owned a car lot. Bill had helped his father repair used cars for resale. John collected vintage cars as a hobby. These men wanted to sell some commissioned product, and they liked cars. Only one man had completed college. Chad was originally an air traffic controller and was recruited by the owner of a dealership to take on the position of general manager. Men who had been working in the field for a while called it "easy" money because they did not have to have a college education to get hired; they did not have to make a long-term commitment to any one dealer and could easily move to another lot if business got slow; and they did not have to do physical labor on the job.

The money was not "easy" for women, however. The majority of them did not grow up loving cars, tinkering with them, or even thinking of car sales as a career choice. Forty-five of the forty-nine women I interviewed entered car sales without ever having worked in an occupation heavily populated by men. Some

had more education than the men when they entered, and unlike the men, they wanted to remain at one dealership because they had trouble getting hired. The women had not even considered doing work that required physical labor an option. Still, women needed money. Divorced and widowed women with a limited education and young children to raise were searching for some way to support their families. Single women doing low-paid service work wanted an opportunity for upward mobility.

The women were not a homogeneous group. Thirty-two had been waitresses, secretaries, beauticians, or sales clerks. Four had been teachers and one a social worker. An additional three had been college business majors, and three had been in the fine arts (photography and portrait painting). One woman had owned a small needlepoint business that went bankrupt. Two women had sold real estate. Two women had tended bar (a job currently employing large numbers of women) on a part-time basis. Two women had done blue-collar work dominated by men. One had repaired and installed telecommunications equipment and another had been a truck driver. Although many of these women had some college education, they were tired of poorly paid part-time work and having to struggle to survive. Even college graduates such as preschool teachers or social workers received little pay. Many women had "burn-out" in their previous work because they had to take a second job to make ends meet. Other issues that pressured these women into leaving their former jobs were lack of autonomy and boredom. One woman said it was difficult for her to "sit at a desk all day." Similarly, another said she found it frustrating to "stand behind a counter for eight hours." A full-time housewife and part-time worker said her part-time jobs were neither fulfilling nor challenging.

In car sales, most salaries were not set, so women could dream of making commissions large enough to allow them to buy their own homes, take vacations, and save money. Thus, even women who had been professionals were willing to sacrifice the prestige of their previous careers to work in car sales. When women discussed their new occupations, they were filled with hope for the future. The descriptions they used for their positions are terms such as "exciting," "challenging," and the "chance" to make a "real living."

Work Histories

Service Workers

Service work extends the private care taking work of women into the public sector of waged service work. Although this is the female equivalent of men's blue-collar or working-class jobs, it pays much less. The women I interviewed both corroborated the literature on this type of work and expanded upon it, showing in specific ways how women envision these jobs and how these jobs affect their lives.[1] Barbara, a thirty-eight-year-old divorced mother of two,

worked as a cosmetologist to support her family prior to entering car sales work. The dull routine of her work as a cosmetologist, the stress from not being able to make ends meet on her salary, and her inability to find hope for the future at her job led to ulcers and hospitalization. On the advice of her doctor and friends, she decided to look for a new occupation:

> I worked for a skin care company, and I really wasn't happy being cooped up in an office behind a desk on the phone all day long taking orders. I need to move around, see people, try new things. So I used to get sick to my stomach, you know, from nerves. Finally I got ulcers and I had to quit. I wasn't making enough to support my family anyway.

Francis, a divorced woman with three children, helped put her ex-husband through college by working at a number of traditional women's jobs. After her divorce, she became a waitress to support her children. She found the work depressing and exhausting but could think of no way out:

> After I graduated from high school, I got married and worked to put my husband through college. I worked in an office and I worked for a salesman. My boss got fired and I was doing his job plus being a secretary and I got a taste of sales and the excitement and I liked it. So I started doing home parties like Tupperware, but I needed more money coming in after my divorce, so I took a waitress job and I hated it. It was so boring, and I had to be on my feet all day. I thought about going into real estate but in my mind I knew it wasn't a good idea because I might have to wait six months or more to make any money.

Nina, a forty-seven-year-old married woman, also worked at a number of traditional women's jobs that were low paying and she believed led nowhere. She blamed herself because she had a limited education:

> I sold cosmetics at a pharmacy and I made $6,000 a year. I got milk free and toothpaste, and deodorant, but I hardly made any money at all. I never made any money before [car sales] in my life. And I used to think this was all I could do and feel bad because I only had a high school education.

Patsy, a forty-five-year-old ex-housewife and mother, worked at a series of part-time pink-collar jobs and also at volunteer positions when her children were young:

I don't like being a housewife. It is not my thing. When my
kids were young, I took any part-time work I could fit in with
their needs. I worked out of my house when my kids were
small. For a while I was a statistical typist. I sold Tupperware
for a while. Then I got involved with my kids' school and I
was the PTO president for a couple of years. Then I went into
market research and it was door-to-door except when I went
into malls and then I did executive interviews. Finally my kids
got old enough and I looked for something that I really wanted
to do that would fulfill me.

Vita, a twenty-nine-year-old, got married right out of high school. Her
husband was in the military so they moved around a lot, and she took part-time
clerical jobs when she could. Before becoming a sales agent, she had been em-
ployed in the office of an automobile dealership as a clerk. Vita had asked to try
sales because she knew the difference between her pay and the pay that the men
agents were getting and she thought she could be successful at such work:

I answered an ad in the paper for an inventory clerk that knew
computers. I was hired to do office work. But I decided to try
sales, because I watched the men, saw how much money they
made, and I thought I would be good at it. And they love me
because I am.

Helen, a middle-aged widow, is the sole woman in my sample who runs her
own dealership. She found it hard to keep the dealership when her husband died
because she also had two children to raise. But because her previous secretarial
work was low paying and offered no autonomy, excitement, or upward mobility,
she took a risk and kept the dealership:

Before I married I worked with an automobile dealer as his
personal secretary. I didn't have an in-hand. I did not work di-
rectly with the customers or with the people or what have you.
It was boring and dead-end. This is different. This is a won-
derful feeling. I can't even explain it. It's exciting, interesting,
challenging, demanding.

Although Helen found secretarial work boring and dead-ended, women profes-
sionals also found their work unsatisfactory.

Professionals

Professions such as teaching, social work, and nursing hold women accountable
to men administrators and lack professional authority and autonomy.[2] Evelyn, a

divorced woman, raised two daughters by teaching fourth grade and moonlighting at pink-collar work in the evening to make ends meet:

> I taught fourth grade at a small private school close to home. But I also had to work a second job because they didn't pay much. I had to raise two daughters alone, so I always worked a full-time job and a part-time job. Whatever it took to make ends meet. I sold jewelry. I was a waitress. I was a market analyst. I was tired all the time and I still had trouble keeping my head above water.

Gina, a single woman, got an elementary-education degree but decided to change careers after her experience with student teaching. She found the work boring and the atmosphere limiting:

> I have a degree in teaching, which I got to please my family. During college I sold clothes part-time. Sales has potential. It is exciting. I like to work with adults. Teaching is dead-end. Your salary is limited. You work with all women.

Ida, a social worker, followed a career in counseling. She moved laterally from working with emotionally disturbed youth to counseling recovering alcoholics at a veterans' hospital, where she received top-of-the-line pay for that type of work. She, too, was dissatisfied with the low pay and blocked mobility. As she put it, she "burned out":

> I have a bachelor's in social work. I started in a youth-service type of thing—lightweight intervention, prevention, short-term counseling. In college I interned with an alternative-to-probation program. I worked directly with the kids and instead of getting a probation officer, the kids got me. They didn't pay me, but it was good on-the-job training. From there I got a job with the county working with the kids in the schools. From there I went to Veterans' Administration. I was a consultant for one of the alcoholism programs and I just burned out. I didn't want to go back into counseling. In the V.A. you move up when somebody dies or retires. I thought, "What have I got to lose? I'll try [car sales], and if I don't like it, I'll go back to what I was doing before." I want to broaden my horizons, do something in a business field, get a lot of background, learn about financing and management. I want to move up. I want some business training. I can always go back, but I don't want to do that for now.

Rita, a recent graduate in primary education, also chose to change her career. She was unable to find work as a primary teacher in public schools in her local area because she had no prior experience. A parochial school offered her work but paid only $9,700 a year, a figure too low to consider because she would need to pay for a sitter for her young child:

> I got a degree from National College of Education as a primary teacher and after borrowing $10,000 to get the education, I found out that no one would hire me where I lived on the North Shore [higher-class suburban area] because I didn't have experience, and I could only get a job at a parochial school where I was offered $9,700 a year. I can't afford to work for that kind of money and be able to pay a sitter.

Creative careers in music, theater, and dance, among others, share some characteristics with professional jobs. There is a sense of commitment and belonging to a community with a common identity and norms as well as a long training period. However, making a living is similarly problematic.

Artists

Careers in the arts are associated with instability in the job market and low-pay except for a select few. People who enter these careers generally do so with the awareness that they will have to moonlight at other jobs to make a living and may have to live a life considered deviant by more traditional members of society. Their work will involve late hours, travel, and unstable living conditions.[3] Family life under these circumstances is difficult, if not impossible. Kate, a divorced woman and struggling artist, tended bar to support her son. She came from a Southern family that advised her to marry and have children. Although she followed their advice, she wanted to work outside the home as well. At the same time, she regretted her choice of profession because she was now divorced and had to support her family:

> I graduated from the Art Institute of Chicago and what happened was, I was unwise in school. I should have gone into math or something. Everyone kept telling me, "You are so talented." So I got into painting without thinking of how I was going to make a living. I couldn't make money at it, so I got a job at night, tending bar. When I got divorced, I had to support my son, so I needed better work.

Laurie was a freelance photographer before her marriage. Her office walls were covered with her photography. But she was not very successful at making money as a photographer:

> I love photography, but I could not make a living freelancing, and I got fed up, so I quit and tried car sales. My days off, 35 percent of the time, I'm here. Sometimes longer. I love it.

Areas of work that generally pay a decent living wage are blue-collar occupations. On the whole, this work is done by men. My sample contains a small number of women who worked at blue-collar jobs before car sales.

Blue-Collar Workers

In blue-collar occupations, pay is related to skill level. More skilled crafts, such as construction work, carpentry, mechanical, or electrical work, offer higher satisfaction as well as more pay because workers have more autonomy and can use their skills to produce something tangible and praiseworthy. However, women who aspire to nontraditional jobs are usually located at the entry level and in more boring, repetitious, low-skilled occupations.[4] Tending bar is at the lower end of blue-collar work and dead-end. Although Leah, a thirty-seven-year-old African-American woman, went to school to learn telecommunications repair and installment, her work paid poorly and did not lead anywhere:

> I got a two-year certificate from DeVries Institute before women ever went there because I wanted to work with technical equipment. My first job was in the telecommunications field doing set up and repair work. But I was not making that much money and I was out in the field every day. It was hard physical labor and I thought I'd like to try something closer to home and better paying. I was raising two kids, and I needed to have more time and energy for them.

Another area of work that has been severely blocked for women is business ownership, where access to capital is required.

Entrepreneurs

Entrepreneurial work is risky. Women do not have equal access to capital or to trust from the banking community or their business suppliers, so the majority of women who were self-employed in the 1970s and 1980s ran small low-profit businesses such as home seamstress, word processing, and cleaning and child

care work. Here the capital output was minimal. Ann, a fifty-two-year-old grandmother, was a partner in a small needlepoint business that went bankrupt:

> My friend and I opened a needlepoint shop. It did not work, however, and we went bankrupt; so I had to find new work. Before, everything I did was always with women. I worked in a bath shop selling to women, and I ran the needlepoint shop with a woman partner. So I looked for something different.

Data on entrepreneural women in the 1990s, however, claims women-owned businesses have doubled, and the types of businesses are growing indistinguishable from those owned by men. The area of largest growth is said to be in wholesale trade and construction. Women entrepreneurs are generally college-educated and come from fields such as engineering, management, finance, and sales.[5]

College Students

The college women in my sample, however, quit school to work in sales. And, as is discussed in the book, they were afraid to and did not have the capital to take the risk of owning lots of their own. Carol, a twenty-five-year-old single woman, left school to go into car sales and remained there because she liked the money:

> I was finishing up my degree, a bachelor's in management, and I needed a job during winter break. Once I got hired, I never left. Originally I wanted to work my way up in a big company like my sister. But I looked at her corporate job and I thought, "No, it's not for me. I can make more money in car sales."

Denise, also a business major, was working at part-time pink-collar jobs to put her self through college and decided to quit:

> I was sick of working my way through college. I was working as a switchboard operator and a deli clerk. I was sick of having no money while all my friends did. I was taking public relations and a degree in that can only get you an interview. Now I make a lot of money.

As previously stated, the women I interviewed did not have homogeneous work experiences when they came to car sales. However, there were common themes in their relationship to work and in the problems their previous jobs pre-

sented them. Car sales was one of the main job opportunities they could find that offered the promise of a living wage or better, especially for women with limited educations. It also represented challenges and excitement in comparison with traditional women's jobs. The decision to enter car sales became these women's particular solution to the problems women face in the workplace.

Getting in to Car Sales

Relatives or Friends in the Business

More than one-half of the women I interviewed embarked on careers in car sales through the help or recommendation of friends or relatives in the business. All but one of these connections was a man. Having a man as a mentor is one of the most traveled routes for women into men's careers.[6] Not all these women were actively encouraged by their friends or family to pursue men's work, but they did use their family connections to get hired. Fran was a typical example of a woman motivated to sell cars by learning about the work from her ex-husband:

> My ex-husband was in the car business for a long time, as well as his father, so I wasn't completely cold to the business. As far as selling and things like that, I certainly did not know how to sell cars and was not encouraged to, or anything like that. But, I was familiar with the business and what to expect–long hours, quotas to meet, highs and low, and the possibility of high commissions.

Ann was also familiar with many of the aspects of the business through family. Although her father and brothers worked in the family-owned business, she was not encouraged to take part in the enterprise. Later, however, she used the family name and what she had learned from observing and listening to family members to get a job selling cars:

> My father, when I was born, he had the business. He had a used car lot. When you're raised in the business, like if your father was a doctor, you would understand hours, you would understand terms. Whatever you're speaking of, your children will pick up. It was really a family affair. I had two brothers in the business. My sister's husband was in the business. But my dad never encouraged me. In fact, he was long deceased when I went into the business and the dealership was long gone. I had no experience, but I used my family's name. I thought, "I will use it to get in the door." They didn't even ask me the

name. All I said was, "I was raised in the business." And, that got me in the door. I went to three dealerships, and two out of the three hired me. This was before women were in, thirteen years ago.

Laurie was talked into selling cars in the family business by her father-in-law:

> The dealership was my husband's and his father's before I got married. I was doing freelance photography and not making very much money and my father-in-law suggested it. He said, "Why don't you try it? If you can't sell photographs, maybe you can sell cars."

Denise had a woman relative in car sales, her mother, so the owner of her mother's agency approached her:

> My mom was the number-one sales agent at Roadman's dealership and when they heard that I was a business major, they called me into the office and said, "Why don't you try this?" I said, "No, thank you. I'm not interested." I didn't know anything about cars. I barely knew how to fill up the gas tank. I thought, "This is a joke." And they talked me into going to a pep-rally seminar for their cars. They were in the process of opening a new store and they figured my potential would be pretty good. You know, I've been here over two years, and it's nice to have money.

Arlene, a bilingual Mexican-American woman, was approached by the owner of the dealership where her husband worked. He needed a bilingual salesperson and he also wanted a woman to work with women customers. At that time, Arlene had no intention of working outside her home, but her children were eleven and thirteen, "not babies any more," and "the money was good."

> My husband was the service manager and the dealership needed someone who spoke Spanish. I was not working at the time. My husband came home one evening and said, "Guess what? I have an interview for you tomorrow." I said, "For what?" "For sales. They need someone bilingual." I said, "I'm not going; I can't do it." But I went the next morning, and we talked and I started on Monday.

Nina was approached at a social gathering by a friend who was in the business. Although she was reluctant and did not think she could do it, she took him up on it:

I met this couple socially, and the male part of the couple owned a few lots. He knew I was looking for work and he said, "Well, would you want to sell cars? We could use a woman's touch." And I said, "Well, I wouldn't know how to sell cars; that's ridiculous." And he said, "Well, why don't you start by selling rust-proofing?" So I started selling after-sales stuff and when my cosmetics job folded, I gave it a chance and I started to sell cars.

Helen inherited her car dealership, but family and friends encouraged her to continue to run it:

When I first came in and took over my husband's business when he passed away, the choice was either I sell it or I run it. I had not worked for twenty years. I had been a housewife and a very shy type of person on the quiet side. I came home and I told my children, and my youngest son just assumed I was going to do it. "Kids," I said, "I have doubts." My daughter said, "You can do it Mom." My older son, my friends, and my family were all very encouraging. I was the first woman automobile dealer in my state.

Women who did not have relatives in the field, were sometimes encouraged and even actively pursued by unrelated management.

Drafted into the Sales Force

Francis, was approached by a sales manager she was waiting on. Although she did not take him up on the job offer at the time, she kept the thought of selling cars in the back of her mind:

I waitressed for about five months after my divorce and one day while I was there, a guy said to me, "You ought to sell cars. I would hire you to sell Pontiacs. We get some women customers who ask for a woman. Why don't you think about it?" I asked around and people told me you had to sell too many American cars to make a decent amount of money. But I decided to take the suggestion and I went asking around and I finally got a job selling Volkswagens.

Carol answered a newspaper ad for a car salesperson. She had intended to work only over the winter break to make some extra money, but she did not tell this to the manager:

> I had three classes left for a degree. I wanted a job for winter break and the funniest thing was I called every ad in the paper. Here I was, sleeping one morning, and the phone rang and it was a car agency. "Would you like to come in for an interview?" And I'm like, "What? What in the hell did I apply to?" I didn't know cause I had applied to so many jobs. I just answered an ad in the paper and when they called me I lied about going back to school. I never sold cars. I had done other selling, telephone solicitations, credit card protections service, stuff over the phone. But this was a lot different. But after I found out what I made on my first car, I decided, well maybe school can wait a little. And, they don't want to lose me. I have just been made finance manager.

Carol was pursued and took the job on a whim. Other women went after the work with no encouragement and pursued management until they got hired.

Pioneers on a Whim

Some women came into car sales on what they considered to be a whim, a sudden decision that it was something they wanted and could do, without any mentors or connections, before dealers courted women. They are the true pioneers. Patsy was a bored housewife with grown children who found herself applying for work at her local dealership:

> We always had Oldsmobiles. But I never thought I would be hired to sell them. I never saw women selling. But one June, on a whim, I approached the sales manager of an Olds dealer and asked if he'd ever consider a woman in sales. He said he'd thought about it. I said, "Well, don't think about it. I want the job." Those are literally the words I used. And, he said he would talk to the owner and tell him and so forth. By that time, I was real persistent. It was definitely something I had determined I wanted to do and was gonna do it. I probably called him every day for two weeks. He said they hadn't talked about it, this that and the other, and finally I guess persistence pays off and I got the job.

The success of these true pioneers in the field, who entered on a whim, with no connections or mentors, before women were courted for car sales, and got hired by walking in off the street and convincing the manager that they had the skills or techniques necessary for sales, have probably made it easier for new women to enter the field, yet numbers for women in car sales are still very are low.

Notes

1. There is a substantial amount of literature on women and service work. See for example, Barbara Garson, *All the Livelong Day: The Meaning and Demeaning of Routine Work* (New York: Penguin Books, 1977); Louise Kapp Howe, *Pink-Collar Workers: Inside the World of Women's Work* (New York: G. P. Putnam and Sons, 1977); Mary Frank Fox and Sharlene Hesse-Biber, *Women at Work* (Palo Alto, Calif.: Mayfield Publishing Company, 1984); and Rachael Kahn-Hut and Arlene K. Daniels eds., *Women and Work: Problems and Perspectives* (New York: Oxford University Press, 1982.) For restaurant/service work, see Susan Porter Benson, *Counter Cultures* (Urbana, Ill.: University of Illinois Press, 1986); Gary Alan Fine, *Kitchens: The Culture of Restaurant Work* (Berkeley: University of California Press, 1996); Greta Foff Paules, *Dishing It Out: Power and Resistance Among Waitresses in a New York Restaurant* (Philadelphia: Temple University Press, 1991); James P. Spradley and Brenda J. Mann, *The Cocktail Waitress: Woman's Work in a Man's World* (New York: John Wiley and Sons, 1975); Elaine J. Hall, "Waitering/Waitressing: Engendering the Work of Table Servers," in *Gender and Society* 7(3) (1993): 329-346, and Robin Leidner, *Fast Food, Fast Talk: Service Work and the Routinization of Everyday Life* (Berkeley: University of California Press 1993). For housework, see Ann Oakley, *The Sociology of Housework* (New York: Random House Publishers, 1974). For saleswork see Frances R. Donovan *The Saleslady* (New York: Arno Press, 1974).

2. For theory on women's professions as semi-professions, see Ronald M. Pavalko, *Sociology of Occupations and Professions* (Itasco, Ill.: F.E. Peacock Publishers, Inc. 1988.) and Rue Bucher and Joan G. Stelling, *Becoming Professional* (Beverly Hills, Calif.: Sage Publications, 1977). To examine problems in nursing, see Nona Y. Glazer, "Between a Rock and a Hard Place: Women's Professional Organizations in Nursing and Class, Racial and Ethnic Inequalities," in *Gender and Society*, (1991): 5 (3) 351-372. To examine problems in teaching, see Jo Anne Preston, "Gender and the Formation of a Women's Profession: The Case of Public School Teaching," in Jerry Jacobs, ed., *Gender Inequality at Work* (Beverly Hills, Calif.: Sage Publications, Inc., 1995) 379-407.

3. Howard S. Becker discusses society's negative attitudes towards musicians in *Outsiders: Studies in the Sociology of Deviance* (New York: Free Press, 1963). However, the women in my study were encouraged to become artists by friends and family, because they were expected to get married and have a husband who would support them. When the women became divorced and could not make a living in their chosen field, they blamed themselves for being "deviant."

4. Many researchers have described ways in which advancement in blue-collar occupations is hindered or blocked for women. See for example: Cynthia Cockburn, *Brothers: Male Dominance and Technological Change* (London: Pluto Press, 1983); Brigid

O'Farrell, "Women in Non-Traditional Blue-Collar Jobs in the 1980s: An Overview," in Phyllis Wallace, ed., *Women in the Workplace* (Boston, Mass.: Auburn House, 1982), 135-165; Marian Swerdlow, "Men's Accommodations to Women Entering a Nontraditional Occupation: A Case of Rapid Transit Operatives," in Dana Dunn. ed., *Workplace/Women's Place* (Los Angeles, Calif.: Roxbury Publishing Co., 1997), 260-270; Susan Eisenberg, *We'll Call You If We Need You: Experiences of Women Working Construction* (New York: ILR Press, 1998); Jean Reith Schroedel, *Alone in a Crowd: Women in the Trades Tell Their Stories* (Philadelphia: Temple University Press, 1985); Mary Walsok, *Blue-Collar Women: Pioneers on the Male Frontier* (Garden City, N.Y.: Anchor Doubleday, 1981); and Linda A. Detman, "Women Behind Bars: The Feminization of Bartending," in Barbara Reskin and Patricia Roos, eds., *Job Queues, Gender Queues: Explaining Women's Inroads Into Male Occupations* (Philadelphia: Temple University Press, 1990), 241-255.

5. See Paulette Thomas. "Closing the Gender Gap," *Wall Street Journal*, May 24, 1999, R12.

6. See Judith Lorber, "Trust, Loyalty and the Place of Women in the External Organization of Work," in Jo Freeman, ed., *Women: A Feminist Perspective* (Palo Alto, Calif.: Mayfield Publishing Company, 1984), 370-378; Rosabeth Kanter, *Men and Women of the Corporation* (New York: Basic Books Inc., 1977); Mary Walshok. *Blue-Collar Women: Pioneers on the Male Frontier* (Garden City, N.Y.: Anchor Doubleday, 1981); and Bruce C. Straits, "Occupational Sex Segregation: The Role of Personal Ties," *Journal of Vocational Behavior* 52 (2) (Apr. 1998): 191-207.

2

GREEN PEA COUNTERS, COUNTRY CLUBS, AND "GIRLY" STORES: THE POLITICS OF DEALERSHIP LOCATION

> The fish [car sales industry] stinks from the head down. Everybody is on top of everybody else. The dealer is always in debt one way or another. Sales agents don't need to know anything about cars. If you can sell 'em quick for a good price, you make a good profit. The whole industry is too unpredictable. The popularity of cars is chancy, and dealers go broke all too easy. A few years ago a Toyota store would fetch several million for a ticket overnight. Now you can't give Toyota away. I know people who bought hot tickets in a hot area and lost. It's a crap shoot. You might as well go to Las Vegas for your money.
>
> –Rod, *general manager of a car dealership*

All car dealerships are primarily concerned with increasing sales and making money. In most dealerships, managers put very heavy pressure on sales agents to make high quotas or else be fired. Dealership policy is to give new sales workers thirty to ninety days to prove they can meet a quota of twenty to thirty cars a month.[1] Because most sales agents cannot meet this goal the attrition rate is approximately 90 percent.[2] This of course, is why the job is termed a "revolving door" occupation by workers. Researchers who have studied the field agree that car sales agents who keep their jobs and are successful must learn to become "wheeler dealers": fast- talking, fast-moving liars who will resort to any means necessary to close a deal.[3] Marketing experts have complained over the years about the overly aggressive techniques used in car sales. "Used car salesmen ... are usually fast talking, shrewd, and quick to high pressure prospects into parting with their money. These methods give [other types of] salesmen a bad reputation" (Mauser 1973:17). And further: "Car sales persons create an unmistakable win/lose situation and bring about pushy stereotypes hung on sales people in general" (Mitchell 1991:171). Experienced car sales agents in my study linked car sales work to prostitution. They called dealerships "meat houses," "cat houses," and "whore houses," places where people sell themselves to others to make money for the house.

23

But the type of atmosphere found in each agency depends largely on the type and size of the dealership, the price range and make of car sold, and the status of the customer. Larger dealerships with average-priced cars encourage competition among employees and little time spent with customers. Management needs to get its large inventory off the lot and fires sales agents who do not sell a lot of cars on a regular basis. Dealerships of any size that sell expensive cars use more experienced sales agents that have a reputation for making sales. Generally there is less bargaining because customers are repeaters and know about and can afford the car they want. These agencies offer special services. For example, serving a lox and bagel breakfast is the rule on Saturday mornings when cars are brought in for service at some Lexus dealerships in Los Angeles.

Middle-volume dealerships with less expensive cars try to increase sales volume by getting "iffy" customers the larger dealers ignore. They track sales workers to make sure they follow a prescribed script with customers. Smaller suburban dealerships also concentrate on "iffy" customers but some also give special services like loaner cars and pick-up and delivery service in hopes of repeat and referral business. There are also one-price dealerships. Some are large-volume stores that sell many makes of cars. Others are small and more specialized. These agencies generally hire new inexperienced agents for straight salary and train them to do multiple jobs aside from selling cars, such as finance and leasing arrangements. Some dealerships attract customers who like to haggle for price. Others concentrate on those who do not. Many of the latter customers are women or persons who can afford very expensive cars.

Dealership Types

"Slam-Dunk-Em" Stores

Larger, high-volume dealerships that sell medium-priced cars advertise more and get more walk-in customers. As a result, sales agents at high-volume stores do not spend time with customers who were not easily sold. They could not afford to let days go by without sales. Frank, a veteran sales manager, complained that "blood baths" were common:

> I came in on a Saturday and at about 1 o'clock we had sold one car. So the owner called me in the office, and he asked me to fire seven new guys. Some of them had only been selling two or three weeks, and he felt that was it.

John, a general manager, hired only agents who could intimidate customers into buying a car:

I want to draw in salespeople that are aggressive. Those are people that pressure someone into buying a car. People will buy things under pressure. They feel intimidated. Right now, as competitive as the market is, the competition is getting real fierce, and not all dealers are going to survive.

Barbara, a relative newcomer to car sales, was fired after three months from a high-volume Chevrolet dealership. She explained how the "big numbers" stores wanted "pushier" people, meaning men, not women:

> If you actually go to a store that is a very big numbers store, they have a little tougher sales people. Many don't hire any females. Their policy is basically "slam every person." They are a "hardball" store. You can't get through the door without somebody trying to attack you. People walk in the store and you ask them, "Are you buying today?" If they're not, you get rid of them. The quicker you sell a car, the quicker you'll get your income. They don't care about repeat business because they get enough first-time buyers. They are just there for the money. They didn't even give me a chance to show what a good job I could do.

Newcomer women did better at agencies that followed prescribed sales methods with management closings.

"Green-Pea Trackers"

"Green-Pea Tracker" stores are usually medium-volume dealerships that prefer to hire inexperienced workers and monitor their sales. New sales agents are trained in a track method, which stresses prescribed sales "spiels" and manager closings. Marvin said each sales agent was trained in exactly what questions to ask and what steps to take the customers through in order to get them ready to buy. Then a manager would take over and make sure the sale got closed:

> This store, we run on what's called a track system. In step one, the salesman is given various specific questions to ask in order to discover what the customers' needs are and how much they can afford so he can choose a car close enough to their price range to keep them interested.

In step two, you have to sell them on the automobile. We take customers for a trial run in the car to develop a desire. You are dealing with a piece of merchandise that a customer falls deeply in love with. There are a lot of add-ons and features they should know about. If you explain to your customer what they are getting for their money, we are going to get a higher profit on the car. This is a business. We want to make as much as we can on a car.

In step three, we sell them on the dealership. The salesman has to explain the service department and how special it is.

I try to monitor things as much as I can, even while the people are here. And, even if they don't buy the car, we'll call a customer three days later and find out how they were treated and make sure the salesperson did their job.

Ida talked about selling under the track system:

They [the management] want you to sell the car that day—of course, that's how they make money. So I am going to go through the nine yards with you and I'm going to show you everything, and if that doesn't work, I'm going to get a manager to see you. But, I hate it because I'd rather do my own thing and let people go if they're not ready to buy. I know they'll come back because I'm good at what I do, but management doesn't trust my judgment.

When women are hired, they usually work at middle-volume green pea dealerships or other agencies seen as less desirable to men. Still, most of these women were the sole female agent at the agencies in which they were employed.

"Country Clubs"

In small-volume suburban stores, the atmosphere is somewhat different from high- or medium-volume dealerships. Sales agents are more relaxed because they usually do not have to meet a quota. Ann's store had a "greeter" that met customers at the door and agents signed up to take turns going on the floor, thereby lessening competition among themselves. Denise said stores like these are called "country clubs" by people in the business because there is less activity and less pressure:

This is a family store. They are wonderful people. Here we have a "country club." It is a family business, and they are

happy to have me. It's much more comfortable. You're not under pressure. You learn as you go along, and the manager gives me pointers. You have goals, but you don't have to meet a quota. They have goals. Everyone has goals. Goals are something you try to achieve, but you know, you don't get shot for not achieving them.

Fran left her first job at a high-volume dealership in the city for a smaller suburban store where she was much happier. Management encouraged her to give customers special treatment, and co-workers treated each other better. However, she sold fewer cars, and made less money:

We do special things for our customers as well as each other. One man comes here from downtown to bring his car in for service. I drive him to the el. Then he takes the el downtown. When he is ready to pick the car up, I'll pick him up. Things that they do here are a little extra special. I'm more relaxed here. I feel real good. You know, over there I could not be feeling well, and I'd be afraid to ask, "Could I go home early?" I was under the gun. If I had to go home early, I'd probably lose my job. They are real human here. Sometimes when it's real slow here, they'll say, "Why don't you go home because you have kids at home." The problem is, it is harder to make the kind of money I made before, and if the dealership doesn't do better, I'll probably lose this job.

Generally, these stores are composed of owners and their families, usually men. So if business does not pick up, outsiders, especially women, are the first to go.

"Top of the Line" Stores

The type of dealership that seems to hire the fewest women is one that sells expensive cars and wants experienced sales agents. Gina moved from a small suburban dealer, where she made a comfortable but limited income, to a high-volume dealer in downtown Chicago that handled expensive foreign cars. Gina said she was experienced and could do what was necessary:

This is probably one of the highest top-of-the-line stores. They sell a lot of cars. They make a lot of money. When they hire

people here they figure, "If you got this far you should know
the ropes and be able to sell a lot of cars." Mostly we hire ex-
perienced salespersons with proven track records. Over here
we're dealing with a better-educated customer. People know
what they want and what cars go for, and they can pay for
what they want, so we better not lose them, and I won't.

I did not find many women at "Top of the Line" stores. I expected to find
women at the newer one-price stores opened in the 1990s, women with no ex-
perience.

"Mega Mall Stores"

Similar to "Green Pea" stores, "Mega" stores hire younger and inexperienced
sales agents that are generally paid a flat salary instead of a commission tied to
the price the salesperson got for the car. Most are one-price dealerships, like
Auto Nation and Car Max, that advertise "no haggling." Surprisingly, there
were no woman sales agents at the first store I visited, and, only one out of the
other five agencies I went to had a woman working the floor. Roger, a twenty-
eight-year-old sales agent explained how buying at his store worked, but could
not explain why there were no women agents at his store:

I have been working here for six months. There's no haggling,
no hassles. You say what you want and we say what's in
stock. Use the kiosk, look the stock up on the computer. If you
have any trouble, I'll be glad to show you how. Eighty percent
of our cars are priced below invoice. Women agents? We
don't have one now. We had quite a few at one time, but ...
I'm a nice guy. Why not use me instead?

Wanting more opinions about one-price policy and women, I read automotive
journals and newspaper articles. I also contacted the National Automobile
Dealer's Association and spoke with a Public Relations Coordinator in the Man-
agement Education Division. She said, "There is controversy over whether or
not it [one-price policy] is working like people wanted it to. Some dealers are
stepping back from one-price policy."[4] She could not tell me why there were no
women at the one-price agencies I visited. Vincent, a middle-aged agent at a
traditional Ford dealership couldn't either. He was more interested in telling me
that there was no such thing as a one-price dealership:

One-price dealerships? Isn't that special! That's bullshit. I
read in the paper yesterday that they are not doing well. Peo-
ple are not that dumb. As long as you have a trade-in or buy a

used car you know there are no two exactly alike. So, there is flexability in the price. You can never say there is no haggling, but they lie.

Yet, Saturn dealerships said they were one-price dealerships, and, they had women sales agents.

"Girly" Stores

Smaller one-price Saturn dealerships are also known to pay a flat salary and hire inexperienced sales agents, but they are the exception when it comes to hiring and keeping women. Tim, a twenty-four-year-old sales agent who worked at a suburban Saturn dealer in the Chicago area said:

> It's hard to find a woman in most stores. We have lots of women here. It's easy for them to get hired and trained. We haven't been here a long time though. We just opened this store ... we are in the formative stages so I don't know how it will go.

Milly, a forty-three-year-old sales agent at a Saturn agency in Pennsylvania, had a similar story to tell and her agency had been there for a longer time:

> We've been here eight years. Women make up three-quarters of our agency. In the office, of course, they're all women. We even have women in the service department. Over half of our sales force are women. They don't want people with bad habits who have sold cars before. All that pressuring people and stuff. Our philosophy is "no haggle-no hassle." The women mostly sold retail before and they do well. You should see some of 'em. The men are younger and aren't as hard working. They use the job to get some money and leave to go to college or something.

In order to understand why there were so many women at Saturn dealerships, I phoned Saturn Corporation and spoke with a sales analyst. She explained, "About 60 percent of our cars are purchased by women. That's how we get our saleswomen. Women purchased a car and thought selling here would be a good fit for them. A large percent of our sales force comes from the rank and

file of purchasers." I also asked about the one-price philosophy and if all Saturn cars really sold for one price. She said, "The price that the retailer determines is the right price for that marketplace or region is what is charged. Different stores could have different prices. We recommend the MSRP price, but do not control the dealer. Everyone that comes into the same store has the opportunity to pay the same price." I also asked if all sales agents were paid a flat salary. She replied, "It is up to each individual retailer how they pay their people."[5]

But at whatever type of dealership they work, most sales agents who make a good living must value selling cars above all else. Staying at one dealership, coming in every day on time, and being faithful to one's boss have little value in a job structure where making a quota of sales is the number-one measure of loyalty. A good reputation is of no use to a dealer whose franchise is terminated because of poor sales. Therefore, sales agents cannot be dedicated to their dealerships or their customers' needs. They must think in terms of personal gain, forced through the positive and negative reinforcement they receive from the industry into conditions of selfishness and greed. Yet the structure of the car sales profession still retains certain unique aspects. The work is challenging. It is exciting and risky. It can be rewarding or devastating, similar to a game of chance. Each time a customer comes through the door of the dealership, the game begins anew. And although sales agents do not control the organization, they can learn to control their play somewhat.

Notes

1. This information was from an article in a magazine distributed to Chevrolet workers. It was given to me by a respondent who was complaining about company policy and unrealistic expectations. See George Rayes, "New People Need to be Well-Trained: Structured Programs Teach the Right Habits," *Pro Chevrolet Magazine* (Aug. 1, 1988).

2. Donna Reichle, public relations coordinator for National Automobile Dealers' Association. phone conversation August 3, 1993.

3. For sociological literature on the bargaining behavior involved in car sales, see Joy Browne, *The Used Car Game: A Sociology of the Bargain* (Lexington, Mass.: Lexington Books, 1973) and Stephen J. Miller, "The Social Basis of Sales Behavior," *Social Problems* 12 (1964): 15-24.

4. Elizabeth Spear, public relations coordinator, National Automobile Dealers' Association, phone conversation May 27, 1999.

5. Kelly McIntyre, sales analyst, Saturn Corporation, phone conversation June 2, 1999.

3

LIFE ON THE FLOOR

One time I was on the phone with somebody and the owner walks by
and he goes, "Why are you being so nice? I want to make sure that it
is clear that if somebody needs prodding you are there to give it to
them. You need more backbone."

—Martha, *six-month sales agent novice*

There are tough women who work in the city. They sell more cars
and make more money. They go in for the close right away and they
get it most of the time. All the sweetness they show when they meet
customers disappears. They have long red claws and are very menac-
ing. The control they have would not make it in a small suburban
store. That is something for a big store with a large clientele. It is
hard, because, like the used car salesman with the white shoes, plaid
jacket, and stripped tie, women get a bad reputation from them. But
they are very successful. They have learned how to make a lot of
money.

—June, *ex-preschool teacher*

Work socializes people. Formal and informal on-the-job training and experience
combine to produce the technical and cognitive abilities, as well as values, atti-
tudes, and social skills, necessary to function within the subculture of a job.[1]
This socialization causes people to behave in ways they may not have before in
order for them to adapt and conform to the common needs of the work group.
Our society seldom questions this type of socialization because it equates learn-
ing to work with becoming a mature adult.[2] However, not all work changes peo-
ple for the better, and selling cars—especially used ones—suggests dishonesty
and deviance to the public. Sales training literature says salesworkers are
"made." And theorists believe they are "made" to behave in a callous, aggres-
sive, and untrustworthy manner because the "kind of thinking required to master
the sales process is pragmatic and instrumental, not reflexive" (Oakes 1990:96).
Successful sales agents cannot concern themselves with the morals and ethics of
their behavior. They are concerned only with the results of their behavior, that
is, how much it profits them. Simmel (1978) felt this fixed focus caused trading
agents to lack character, objectivity, and commitment to the welfare of others.

When workers are trained to be concerned only with their own success, it is difficult to build trust.[3] Each person in the transaction is in a situation in which he or she must have defensive strategies in order to negotiate his or her way in the system. Trust in a community involves openness. There is a boundary around the group, not around the person.[4] In the community of car sales, everyone knows everyone else is "out to get you," so workers are warned to get others first.

Learning the Trade

Informal Training

There are two types of informal training. Anticipatory socialization is a type of informal training that occurs before one is actively involved in the work. It refers to imagining or anticipating what it would be like to be a member of a group of which an individual is not presently a member on the basis of information given by people acquainted with the occupation.[5] Once on the job, informal training in occupations is usually gained through peer networking that occurs once the individual is accepted into the work group or community. People learn what to expect from the job and how to handle themselves by getting insider information from those already experienced in the role.[6]

Mentors, Friends, and Relatives

Women in car sales discussed receiving advice from individual mentors and friends who were familiar with the car sales business. These women developed assumptions about the work from these informants. They were given insider tips and advice on how to avoid problems with management and co-workers before they began to work. Fran said her ex-husband prepared her for what to expect in the business by cautioning her not to trust anyone:

> My ex and I are friendly, so I got a lot of knowledge from him as far as what happens in a car dealership. I was coached as far as "watch this and watch that" because this is typically what happens to newcomers at dealerships—other salesmen steal your customers, management does not credit you for the actual number of cars you sell, and buyers lie to you about their credit ratings and what prices other dealerships gave them. So I had somebody watching over my shoulder and warning me to look for certain types of things.

Ann's brother similarly cautioned her to distrust everyone in the business:

> He said, "I know many people in the business, but I don't trust
> any of them. You've got to understand their motivation.
> They're in it for the money. If they are making money, if they
> are successful, they feel whatever they do, they must be right."

Barbara's steady date sold cars at one time. He warned her not to trust customers:

> Watch out for customers. You spend time with them and they
> won't give you their trust. They won't give you their real tele-
> phone numbers, and some of them won't even give you their
> real names, because they're just shopping or their credit is bad
> and they aren't really going to buy.

Denise's mother, Marsha, warned her to distrust sales agents at other dealerships:

> Salesmen at other dealerships will say anything to take a deal
> away. They "low ball." They take customers out of the mar-
> ket that way and try and talk them into buying another car
> when the car they promised doesn't come in. Don't cut your
> commission just because a customer was lied to.

And Nora dated a car sales agent who told her to distrust management because managers lied about the prices cars were taken in for so they could cut commissions:

> Owners doctor the books. They register the car at a much
> higher price than it was really bought for, so their profit is
> probably double what their books show. Try to find out what
> the car was really taken in for and keep your own books.

Thus these women were taught to distrust co-workers, customers, and management before they began to work. And, once the women began to sell, they found that bosses, co-workers, and customers also distrusted them.

Bosses and Co-Workers

Women new to car sales wanted support and help from bosses and co-workers. They were moving into a new situation and, as yet, did not have a good perspective on themselves. Women devalue themselves and think something must be wrong with them when they understand the world differently from men.[7]

Women respondents entered the field with different backgrounds from men and were not quite sure how to apply their experiences or even if their experiences were valuable. Their self-concept was low and their fears were validated, because what newcomer women saw in the men they worked with was distrust and a lack of faith in women as agents. Edith and Joan, two newcomers to car sales, summed up the inferiority newcomer women felt when they were hired and the ways in which their bosses and co-workers reinforced their feelings of inadequacy. Edith said:

> I can't say that I was overly confident about taking the job, and when I started, the manager said, "I don't know what is going to happen. I don't know how the customers are going to accept you. I don't know how the salesmen are going to accept you."

Joan, a newcomer of two weeks, was also concerned about being able to do the work:

> I didn't know anything. I said to my boss, "Give me a month. You don't even have to pay me. I have never done this before. I'm coming in fresh. I don't know how good I'll be." And he said he was as worried about hiring me as I was about doing the job.

Men's lack of trust in women as colleagues concerns their cultural role as wives and mothers. Women are expected to put their work before their children's welfare or domestic needs and are expected to drop out if family responsibilities require it.[8] Women's initial self-concepts based on fear of incompetence are usually enhanced by harassment related to these assumptions regarding their primary loyalty. Three sales managers–Pete, Marvin, and Larry–exemplified this negative point of view. They wanted women workers because other women liked buying from them, but they thought most women could not be good car salespersons. They based their judgment on two major stereotypes of competency in woman workers in male fields: a lack of technical knowledge and presupposed drop-out due to family responsibilities and breadwinner husbands. John, the general manager at Wendy's dealership, said women in general did not do well, but a token woman on the lot was okay as long as she sold to other women, because most men customers did not like dealing with her:

> As far as women in the business, I think they are finding they really don't like the business. You don't find very many women that are real, real good–that are real outstanding in the business as far as sales. A lot of people don't even like talking to a woman when it comes to a car. A lot of men are offended. I can give you a perfect example of this woman that we hired.

She had a customer about a week ago, and she was explaining the car to him. He just jumped all over her. He said her information was inadequate. He started telling her the thickness of the metal. He started getting into real detail things and she didn't know how to respond to it because she doesn't really know the technical background of the car. I think dealerships try not to have too many women because they're weaker than men. Yet, on the other hand, I like the idea of having a woman because a lot of women that come in the store like to deal with a woman. They feel they can trust her more.

Frank, a sales manager at a dealership next door to Ida's and under the same ownership, brought up old stereotypes, asserting that women would not advance in the business because they were too concerned with marriage and family problems or were supported by husbands:

I've had women working for me, but as for becoming managers or owners, I think it would be very difficult as far as the way the hours are set up. The latest I have left the store is 4:00 in the morning. For a woman because, quote unquote, a lot of women are married, and therefore it is additional income, not sole income—or they have kids to take care of.

Mike, an ex-manager brought up similar stereotypes. He felt that divorced women with children would always be concerned about what was going on at home with the children. And single women would be looking for husbands, getting married, and quitting:

I have had a couple women working for me over the years. The problem I have had is that many women try to sell cars with their own personal life in disarray. You get into these divorcees where they have an unstable personal situation. I had a woman coming to me looking for a job one day and she had a baby less than a year old. I looked her right in the eye and I said, "Go home and raise the baby. You don't need the job." Her husband had a job and she wanted to get out of the house and sell cars. Now I can't believe any woman in her right mind would take a job from 9:00 [in the morning] till 10:00 at night with a young child at home. One of the problems we run into with divorced women is they've got the children. Something happens in school or after school and they have to run home. The other problem is with younger women you don't know how soon they are going to get married and have children and then their family life will control their activities so

they don't want a job anymore. They don't go into it as per-
manently as men.

At most dealerships, themes of gender-related harassment and overall dis-
trust were evident and vividly illustrated. These themes were replicated in
differing forms and woven throughout the varied paths of women workers as
they continued on in their careers. This added to the framework of the
distressful nature of the business and its resulting lack of support for workers.

Formal Training Methods

In sales occupations, the content and substance of formal knowledge transmitted
by administration is mainly concerned with meeting a payroll and turning a
profit for the agency.[9] In car sales, that means how to sell enough cars at a high
enough price to make money for the dealer. The reprimands sales agents get
from their bosses come because they are not paying attention to those things the
sales philosophy says they should. For example, perhaps they have not been
aggressive enough, have not created a great enough need or desire for the prod-
uct in the customer, or have let the customer go before the manager got a chance
to close the deal. Formal training, according to informants, ranged from struc-
tured one- to two-week programs conducted outside or on the site of the agency,
to one- to three-day seminars and workshops, to less structured offerings, where
management trained newcomers on a one-on-one basis, to various types of
quasi-apprenticeships. However, training did not always begin when newcomers
started work. A majority of women said they got little to no training before they
were expected to sell.[10]

In-House Management Training

What training newcomers did get centered on issues of customer manipulation.
From the very first in-house training session, agents are told to convince cus-
tomers they (agents) have a genuine interest in them and their needs, rather than
just in making a sale. This is especially stressed at one-price dealerships. Sales
agents must convince customers that they are on their side, getting them the best
possible deal, when agents actually have no real control over the final price.
This is an exaggeration of a problem that we all confront in many ways in eve-
ryday life: convincing people of who we are and that we are genuine, especially
when we have an interest in their behavior.[11] By understanding the in-house
training sessions, we learn about dealers' perspectives on customers, employees,
and work. First, the sales agent must learn to be aggressive in order to create a
need and desire in the customer. Sales agents do not just sell a car; they must
also sell themselves, the service department, and add-ons. In addition, the man-

ager makes sure the new sales agent, anxious to get a sale, does not sell the car for less than what the dealership wants, because management controls the closing.

There are a variety of ways in which new sales agents understand this training situation and learn to manage it. Through training, they begin to reconstruct their understandings of the sales encounter and how to pursue a customer. Jean, a ten-year veteran, said:

> That's how people cut their teeth in the business. The more inexperienced people tend to go to track or one-price stores. They get hired there because that way management has more control over them and the customers and makes sure the dealership gets a high price for the car. At my dealership I do my own thing. I've been in the business for a while so I know how to sit down with the customer. I don't need their crap.

Betsy, a two-year veteran who left a track store, agreed. She said that she was forced to use a sales spiel that she thought inappropriate in many cases, and that the manager interfered with her completion of sales as well as sexually harassed her:

> They had a ten-step process that they wanted people to follow. They wanted new people, everyone that had never been in the business before, for the purpose of training them the way they wanted them trained. They wanted to have complete control over you which they did beautifully. You role play. I always started out, "Welcome to Jones Chevrolet. My name's Betsy. May I assist you?" Then you ask the customer questions like where they live, how long they've been on the job, what they did for a living, if they bought the car they were driving new or used, then you show them the car. You open the hood. You tell them about the extras. You drive the car with them. You drive their trade-ins. If you didn't get the answers to the questions, you were sent right back out to ask the customer. You had to do all the steps their way. This is basically what they did in the training session. They just taught you the steps. They didn't teach you anything mechanical or technical about cars.

Some novices liked the track method because they were not sure they could close on their own. Edith, in sales for ten months, learned by watching her manager. She said, "I am new. I don't care if a manager does it if I can't close it. I'll come right in and stand while they are closing. I learn that way." The uncertainty of the newcomer is an issue here. New sales agents are uncertain about learning the ropes; they know their salary and their job depends on how suc-

cessful they are. The track method adds some control in the situation. Even if control is given to the manager, the newcomer feels more secure about closing the sale:

> I was not allowed to close a deal by myself. I had to present all the information to a manager and say, "Where do I go from here?" He'd say, "Want me to close this deal for you? Well, what are you gonna do for me if I close this deal for you?" And, oh, my God, while he was harassing me, I would see my customers leaving! And then he would turn and run out the door after them and talk to them in the parking lot. Sometimes he would sell them, so he would help me, but torture me first.

At one-price dealerships, sales agents may not need to go to a manager to get a price. But, they still have a routine to follow, according to Roger, a sales consultant:

> The customer usually sees a greeter first. Then I explain the one-price concept to prove to the customer that they are getting the best deal possible. I interview them and find out what their needs are. Then I help them find the right car with the right features and we go for a test drive. If we agree on the car, I bring them to the finance specialist.

Other new sales agents did not agree with the philosophy behind routines or track methods. Leah said she knew how to sell by instinct and not by following a prescribed sales program that called for cornering every walk-in and going through a long sales talk and asking a series of prescribed questions. But she was unable to identify what her skill or innate quality was:

> I am a human being. I possess certain innate qualities that allow me to know when to strike and when to be still. If I thought it was more advantageous to let this guy go at this particular time, having given him what he came in for, brochure information, whatever, I'm going to believe that when it is time to seriously shop, he will come back and spend the necessary time involved for the amount of money he is spending.

Because management at some dealerships checked up on every walk-in, sales agents had to justify why walk-ins did not buy a car. Leah, who had too many customers leave, excused herself by saying, "He only wanted a brochure." She was reprimanded by her manager, who expected her to keep customers long enough to turn over to him. Sales agents such as Leah were punished if people left without getting a sales pitch or seeing a manager. She said, "I have been

threatened to be suspended for a day, no pay." My general manager said, "Listen, nobody can exit people until I see them. I have not let anybody else let people go. You're not going to start."

As previously mentioned, autonomy was a prime motivator for many women to pursue a career in car sales. Loss of autonomy in this area was upsetting to women, who described autonomy as the freedom they wanted in deciding how they were going to sell and the excitement they felt in creating a successful sales style. They spoke of the enjoyment and satisfaction they received from creative interactions with customers. Most men defined autonomy differently. Regardless of where they worked, men sales agents agreed they had to learn to follow a designated script to produce desired outcomes early in their careers. They did not feel they had freedom or autonomy in how they sold. Instead, men found freedom in their ability to easily find another job if things were slow at their dealership, or if they got fired.

Seminars

Sometimes dealerships contracted out for short seminars to be held on their premises or sent people to seminars or workshops of varying lengths. This training covered attributes of new car models being added to a line. Carol, who had been in business over two years, described this training as helpful:

> I went through a week of in-house training. I watched films and read pamphlets to get product knowledge. You have to know your automobiles. You have to know the product that you are selling. You have to know each individual car, car line, colors, options, add-ons.

Other seminars relied heavily on managers. Managers gave sales agents product brochures and showed them in-house videos on the cars. Timing was an important issue in this training. Even the best of programs were held at times that did not necessarily coincide with the hiring of newcomers, and the sporadic and uncoordinated manner in which most training was presented meant that some agents did not attend training sessions until long after they had started selling cars. Most agents got little to no training before they started selling cars. Isabel was put on the floor on the busiest day of the week, after only two days of training, and felt this was too much pressure for a novice:

> The general manager said, "I will teach you." Thursday I watched videos on a closed circuit TV about the product. The next day he said, "Now say this and do that and bring the deal into my office." Saturday he said, "You're going on the floor." He worked me twelve hours that day, no lunch, no

breaks, no nothing. I think he really wanted to see how far he
could push me before I cracked.

Martha started selling without formal training. Then she got fired and went
to a new dealer. There she got more information than she needed on product
knowledge:

> I didn't really get to go to any classes until I had been in sales
> for about six months because they offer them at weird times,
> and I got fired after three months on my first job because sales
> were slow. At my new place, my training has been all on
> product-knowledge basically about the car. I went to a work-
> shop, where I learned physically about the car, getting in and
> out of the vans, campers. Then they sent me to a class, like
> when the [Audi] Fox first came out we all had to get certified
> about the Fox. They told me things—like colors they came in
> and stuff—I already knew about from experience and reading
> the brochures. The owner says he wants to make sure his em-
> ployees are taught so they can make money because he would
> rather they stay here than have a turnover. But, in the short pe-
> riod of time that I've been selling [6 months], the training has
> not helped me. I know I have to use my own personality to
> sell, because that's what it's about. But I'm not sure how to do
> it.

This is an interesting comment on socialization and the career. Martha was
having difficulty becoming a car sales agent. As a group, newcomers differed in
their reactions to training and were uncertain about what they needed or wanted.
Most women had no prior sales experience. All these women wanted to know
more about cars, including the women who had prior sales experience with other
products. All were dissatisfied with the initial training they got and talked about
using natural ability to sell their first cars. The novice woman was confused,
saying, "There is something I need to know but I can't tell you what it is." To
add to this confusion, many managers sent new women out on the floor during
the first week with no training, giving them advice such as: "Follow someone
around. Here you go, sell cars! Go ahead kid, sell!" Sales agents called this the
"sink or swim" method.

Apprenticeships

In situations in which management did not train newcomers and seminars were
unavailable, newcomers tried to attach themselves to a more experienced sales
agent. Despite the fact that management often suggested this approach, men

were resistant to accept a newcomer, especially a woman, as an apprentice. More experienced car sales agents did not generally bother with newcomers until they had proven themselves. Men sales agents did not want to be followed around by women trying to learn their jobs. Distrust was especially high because women were seen as a foreign presence in the work culture of car lots. To follow an experienced sales agent around was therefore a difficult, if not an impossible, task for a woman entering the field.[12] When newcomers like Isabel went to men for help, they were ignored or refused. Isabel said both new and experienced men ignored her:

> I missed the training program, so they told me to follow someone around. Actually I had to be on my own because hardly any salesmen would talk to me because I was infringing on their territory. Guys that were here for a long time didn't care about me, they cared about themselves. And new salesmen wouldn't talk to me either.

Jean recalled her early days as a sales agent and the cliques from which she was excluded:

> Every sales floor has little cliques. They use each other as sounding boards and support systems. If you have a sales floor that has twenty people, you can have six in one clique, six in another clique and six in a third clique. Then you have a couple loners–usually a woman or a minority. I am not on the sales floor anymore. When I was, it was hard to get in with any male clique. If I would walk over, they would walk away or ignore me.

By contrast, Bill, a newcomer who worked at Ida's store, explained his experience:

> We are a team. We help each other. We are in it together and trying to make our store the best in the business. If there is something I don't know, one of the guys is always ready to help me. We spend weekends and evenings together talking things over and watching ball games.

Yet, this is not always the experience of male newcomers in sales. Christopher, a beginning chemical sales agent whose progress I followed for a year, was allowed to join the group but was kept on the fringes and got little help:

> Sometimes a bunch of us would meet for breakfast, but the more experienced guys wouldn't discuss sales with me. When I asked other men about what chemicals were best for certain

cleaning jobs, they gave me the wrong information. I knew they talked to each other about which chemicals to push because they paid higher commissions. I knew they stold customers from new sales agents who dropped out after a few months, even if they weren't in their territory. But they wouldn't tell me those things.

Therefore, incoming men sales agents are also excluded from the work group. However, while men are excluded from insider information, women face a very different experience. They are also subjected to physical and verbal sexual harassment as a means of forcing them to keep their distance. Yolanda talked about what she learned from her attempts at apprenticeship:

When I first started, I wanted to learn from the guys, but that led to stuff like "Jesus Christ, why don't you go out with me? I've really got something to offer you. When are we going on a date? C'mon. Sex between us would be really great." If that didn't get me to leave, somebody would say "Leave the room so I can tell this joke." This one guy finally said, "What are you doing here? You're taking up space where a male could be supporting his family." Now I keep my distance.

Thus, right at the start, most women learned that the sales floor was male territory on which they should tread carefully. Through sexist jokes, exclusion, and other forms of harassment, they began to understand that they were infringing on male territory and were seen as potential competitors.[13] If they succeeded in making a connection, they would learn how to do their job and they might steal a sale from a co-worker. The problem with informal training and following people around is that you must rely on your potential competitors to teach you what you need to know. Most inexperienced women therefore went out on the selling floor with little training and no support system.

Selling the First Car–Luck and Magic

In occupations such as car sales where there is a very short training period that provides only minimal skills and a rudimentary sense of what membership in the occupation means, most of what makes the person a member of the occupation is learned on the job. "In many cases, learning a job and doing it are one and the same" (Pavalko 1988:105). With minimal training, some women sold their first day out. When asked how they did it, they were not aware of what skills they used and gave themselves little credit for their success. They said it was luck or that it came "naturally." All women sales agents told me they began selling before they were certain of cars and sales techniques. They thought they

did not know enough and needed to know more, but when they made a big sale they said they discovered they did not have to know very much in order to do it. They spoke in fatalistic ways. When they made a sale, they did not understand what they were doing or how they were doing it. They knew they had something in them that came out, but they did not know what it was. They though they had not taken an active role in the sale. This passive voice was part of their self-concept. They said their sales were a "matter of luck" rather than ability. They said "I had nothing to do with it," a very passive way of understanding their success. They saw chance, luck, and then magic as the cause of their success. Dorene was unexpectedly hired at a dealership that sold expensive foreign cars. She talked about an "easy" first sale where she did not even know what she was doing:

> I'll tell you the first sale because that one I remember very well. That's when they hired me to sell Alfa Romeos and I never saw one and I never heard of them. They didn't even have one in stock. They just said, "You're gonna sell Alfa Romeos." And my first thing was, "What is an Alfa Romeo?" Well, I was there for about a couple weeks and it was right after the auto show and a young dentist came in with his wife and he had his hands in his pockets, jiggling his money, and he goes, "I want to buy a car." And I go, "Well, what kind of car do you want to buy?" And he says, "I want to buy a Spider." And I said, " Well, we don't have any." And he goes, "Well, I want to buy one." And I didn't know a thing. It was my first car. I never wrote up a deal or anything. I was like, "Well, okay, what would you like in it?" So we sat down and we started writing this deal and I didn't even know the price of the car. I wrote down everything he wanted. I found out what the list price was and I wrote it down. I sold him an alarm, which I was good at, because I sold alarms before. I sold him a radio and I knew about those. I sold him everything there was. I wrote it all down. I got a $5,000 deposit from him and he took his credit out and I knew nothing. I went into the boss and he almost died. So he goes, "Don't lose this one!" It was an order car and we called New Jersey immediately and ordered the car for him. It was the most exciting thing I ever did. After that we laughed and the guy even laughed when he came in to pick up the car. He goes, "You were new at selling and I was new at buying. I bet you really screwed me." And I did. I made more money on that car than I made on a Mercedes. I didn't even know I was doing it. It was really fun, and I said, "This is so easy."

For many women, this is how it worked. They started out selling without know-
ing how or why they made the sale. Roberta told me the skills she brought from
her previous sales work with Tupperware helped her with her first sales, but she
did not recognize what her specific skills were. Even Renita, who worked at a
top-of-the-line dealer, could not say how she made her first sale. "My first
month I sold a new and a used Rolls Royce. I got lucky." Betsy, who had been
selling for over two years, still described her ability in vague terms:

> It comes natural. At first the manager told me what to do.
> Now say this or do this and bring the deal into my office and I
> ended up selling a convertible. You know what was good?
> First of all, I was lucky. If it was a bad experience, it would
> have been a real trauma. Once you get one success in any-
> thing, it will breed another and another.

Bev was the only sales agent at her suburban store during the first two
weeks it was opened. So although the manager told her to watch the other sales
agents, there were none and she sold by "magic":

> They said, "Don't worry about selling for a couple months.
> We'll put you on salary. Just watch all the other salesmen and
> see what you can learn." It turned out I was the only sales
> agent for about two and a half weeks. I sold a convertible my
> very first night. And I'm like, "What am I going to do now?" I
> went to our manager and I said, "They said, 'Yes'." And he
> said, "Well go write it up." And I said, "How?" It was funny.
> It was magic.

Woman attributed sales to qualities that were out of their control, such as natural
ability. Yet often, they were using skills learned from experiences in service
jobs or in family situations which taught communication and interaction skills
that they carried into car sales. However, they negated and minimized their ex-
periences because much of what they did was invisible to them. It is these finely
honed skills that novice saleswomen called upon to sell cars. Because they are
unnamed, they were not treated as learned skills but as natural attributes.[14]

Though women newcomers did not know why they had early successes,
those that did agreed that selling their first car was a turning point in their ca-
reers. They had new positions as car sales agents and new self-concepts and
identities. It gave them an incredible high that led to the confidence needed to
sell more cars. They were hooked into staying in the field. Carol talked about
the turning point where she decided there was nothing she would rather do than
sell cars:

> I love this business. I really do. It's great. It's crazy, but it gets
> under your skin and there's nothing else for you to do. You

really wouldn't want to do anything else. I can't explain it. I feel good about myself. Every time I have a customer come in, it's a challenge all over again, and the sky's the limit.

Cathy also talked about expanded horizons. Whereas before she was a struggling waitress with a limited income, now she was a successful career woman with limitless options:

Before I was unhappy and depressed. But this is different. It's very challenging. You go from high to low and there's really no middle. You're either on top or you're on the bottom. But, I'm successful and there's no limit to what I can do.

Thus filled with hope, inexperienced women began to learn the ropes and negotiate the hostile environment of the dealership, eventually understanding what skills they needed to use to sell cars.

Notes

1. Symbolic interactionists theorize that socialization is an ongoing interactional process and that we can only see ourselves in relation to our community. Furthermore, our selves are continually being constructed and reconstructed in interaction and negotiation in this community (Mills 1959; Denzin 1978). Work is such a community. For literature on socialization through work, see Howard S. Becker and James Carper, "The Development of Identification With an Occupation," *American Journal of Sociology* 61 (1956): 289-298; Everett C. Hughes, *The Sociological Eye* (Chicago: Aldine 1971); and Robert A. Rothman, *Working: Sociological Perspectives* (Englewood Cliffs, N.J.: Prentice-Hall, 1987).

2. Erik Erikson, *Identity: Youth and Crisis* (New York: Norton, 1968).

3. If workers are to behave in a responsible and ethical manner toward each other as well as those they service, they must have values that encompass more than their own perceived needs in the immediate situation. Furthermore in order to recognize their own ethical involvement, workers must experience "an element of self-determination, freedom and the demand for responsible life enhancing interpretations" (Quigley 1994:54). For literature (both theoretical and in applied work settings) on trust and what conditions are necessary for its development, see T. R. Quigley, "The Ethical and the Narrative Self," *Philosophy Today* 38 (1) (1994), 43. Lawrence A. Blum, *Friendship, Altruism, and Morality* (Boston: Routledge and Kegan Paul, 1980); Morton Deutsch, "Trust and Suspicion," *Journal of Conflict Resolution* 4 (1958): 165-179; Fred Davis, "The Cabdriver and His Fare: Facets of a Fleeting Relationship," *American Journal of Sociology* 65 (1959):158-165; Jack Haas, "Learning Real Feelings: A Study of High Steel Ironworker's Reactions to Fear and Danger," *Sociology of Work and Occupations* 4 (1977) 147-170; and Robert Jackall, *Moral Mazes: The World of Corporate Managers* (New York: Oxford University Press, 1988).

4. Erving Goffman, *The Presentation of Self in Everyday Life* (Garden City: N.Y.: Doubleday and Company, 1959).

5. Ronald M. Pavalko, *Sociology of Occupations and Professions* (Itasco, Ill.: F. E. Peacock Publishers, 1988).

6. George Ritzer, *Man and His Work: Conflict and Change* (New York: Appleton-Century-Crofts, 1977).

7. Carol Gilligan, *In a Different Voice* (Cambridge, Mass.: Harvard University Press, 1982).

8. Judith Lorber, "Trust, Loyalty and the Place of Women in the External Organization of Work," in Jo Freeman, ed., *Women: A Feminist Perspective* (Palo Alto, Calif.: Mayfield Publishing Company, 1984), 370-378.

9. C. Wright Mills, *White Collar* (New York: Oxford University Press, 1951).

10. Employers utilize extremely simple methods of formal training with low-status employees because there is little danger that a single employee can cause damage to the operation as a whole. If an employee does not produce the desired results, he or she can easily be fired and replaced. See Ritzer, *Man and His Work.*

11. Goffman, *The Presentation of Self in Everyday Life.*

12. This situation is similar to those of blue-collar women in studies by Mary Walshok (1981) and women medical interns studied by Cynthia Fuchs Epstein (1988) who had difficulty finding men to mentor them. Rosabeth Kanter (1977) finds women in corporate management having similar difficulties because they are token women in territory belonging to men. They eat in separate lunch rooms and are not included in informal gatherings where insider information is passed along. Jessie Bernard (1964) finds academic women are also excluded in this way.

13. This is found to be the case in other occupations dominated by men, such as coal mining, police work, and the military. See Rustad 1984; Schroedel 1985; Walshok 1981; Yount 1991; Zimmer 1987. It is also true for newcomers in other high-commission jobs such as insurance and commercial real estate. See Leidner 1991 and B. Thomas 1990. And, it is true for professionals such as women lawyers. See Rosenberg, Perlstadt, and Phillips 1993. For a current anthology see Dana Dunn. *Workplace/Women's Place* (Los Angeles, Calif.: Roxbury Publishing, 1997).

14. See Arlie Russell Hochschild, *The Managed Heart: Commercialization of Human Feelings* (Berkeley: University of California Press, 1983) for discussion of emotional labor in service work.

PART TWO
ON THE LOT

4

PINCHES, PATS, AND POKES:
NEGOTIATING THE HOSTILE ENVIRONMENT
OF THE SALES FLOOR

I had a baggy skirt on one day and I went up the steps to the podium to where all the used car slips are and I was looking for a particular deal and my boss, the general manager, came out and he thought he was funny having a good time, and he took a camera and stuck it under my skirt. It was an In-stamatic and he took a picture. And I hear all this laughing. I saw the red light coming on and I went, "Oh!" I chased him into his office and I said, "What is that?" He had pulled the film out by then and I grabbed it. And I was mad. I put it in my purse and I remember telling them off and getting real mad at him, and he's laughing because he thought that was just the fun-niest thing. And then they pat you on the butt, like this.

–Yolanda, *in car sales less than a year*

When I would sell, the guys at times resented me. They used to say, "What do you need to sell a car, a bra?" If I was five minutes late the boss would send me home. They made me an example.

–Nina, *five-year veteran*

Because most beginning women agents have not worked in fields traditionally dominated by men, as noted in the previous chapter, they are not sure how to behave on the job in order to achieve successful interactions.[1] Now, they worked daily with and among men who assisted with and approved closings, men who took care of repairs and got cars ready for delivery, men who sold add-ons such as warranties and approved loans, men who appraised trade-ins, men who gave them information on the availability of models, and men who assisted them with customer demonstrations and other matters. Success in car sales for women re-quired adaptation to this environment. In addition, sales agents' hours were very long. They spent more than the average forty-hour workweek at the dealership. Depending on the dealership and specific position, the agents in my sample worked between forty-five to ninety hours a week, averaging about sixty-five

hours. The most difficult times were the consecutive twelve- to fourteen-hour days. Kate called these "bust-outs":

> Normally, you're gonna work three to four "bust-outs" in a row, which is nine to nine or longer. You're exhausted, and then you get a day off, but all you can do is sleep that whole day.

Most of the sales agents' waking hours was spent at the dealership. Newcomers had to learn how to deal with the boredom of the long hours, because not all or even most of this time was taken up with structured activity. Since they took turns getting customers and had to be on the floor to get the customer when it was their turn, respondents said there was a lot of "open" time. Generally management did not allow agents to watch TV, read a book, play cards, or do anything like that. So, "open" time was spent staring into space, making small talk, or trying to generate some kind of business by soliciting customers on the telephone or by mail. Evelyn said that men agents at her dealership tended to get together in a group and make small talk to relieve the boredom. This talk usually consisted of "telling each other what a good job they were doing" or "telling dirty jokes" to pass the time. It was difficult for new women to join in this talk because most of the "jokes" were sexist or racist. The effect of the joking was to alienate Edith from her co-workers:

> For four days in a row, I worked twelve-hour days. They were very long, hard hours. What got me was I am one of these people that are very nervous and I like to do things. When I would get done calling people and this and that, I sat around. And they wouldn't allow us to read books or anything except sit there and watch the lot. You get tired of that. Then I would try to make conversation with the other salesman, of course. They were very gross. They don't hold back. Guys joke around here. I would think, "I don't have anything in common with these people."

Using jokes is a common way to keep people out of groups.[2] Men car sales agents also showed women that they are outsiders by playing gross practical jokes. Pearl recalled going to a sales meeting where the "guest speaker" was a local prostitute who did a strip tease before the meeting began:

> I was kind of excited to go to my first sales meeting, being the only woman at the agency. What they didn't tell me was that they had paid to see a stripper before the meeting began. The guys were all yelling and screaming and, I was supposed to sit through this. I left. They did a number on me all the time. They didn't cut me any slack on used cars like they did for the

guys and they expected me to hang out in local bars to drum up business for the lot.

This humorous harassment has serious results. It creates a difficult or impossible work environment for women and keeps men and women workers apart. Ultimately, such harassing humor "further reinforces men's control over the women with whom they are in direct contact" (Mulkay 1988:146). In car sales it alienated women, kept them away from the door, and gave men a better chance to approach would-be customers.

During my visits to car lots, I was always approached by a man sales agent before I had a chance to locate a woman. Men hovered around the door in small groups, telling jokes, and waiting to pounce on new arrivals. Keeping women out of these groups kept women out of sight of walk-in customers. This hampered women's chances to make sales and gave men control over the sales floor. Thus, early in their careers, the women I interviewed had to seek territory not occupied by men. As a result, most women "working the door" took the leftovers: customers who men did not want because they were not considered "serious buyers." Inside the dealership, managers placed women in less accessible geographic areas in relationship to the sales floor. They were given desks close to less expensive cars and told to hand over customers who wanted expensive models to men agents. This practice was to the women's disadvantage because the customers they could approach were a limited group.

In addition, management policy made it difficult for women agents to socialize, even if men asked women to join their groups. Women were expected to do the "shitwork" and "housework" in the dealerships. Like secretaries, they were expected to be occupied at all times. Managers kept them constantly busy mailing out flyers, helping out with computer work, and locating cars at other dealerships for men. Managers did not ask men agents to do these chores.

Newcomer women reacted in various ways to this workplace harassment. Although none liked it, if they wanted to work in car sales, they had to find coping strategies. Some women who had never before worked in an all-male environment or experienced this type of harassment cried.[3] Carol said if a woman agent cried, she would only get harassed further; she found crying a poor strategy for negotiating co-worker interactions in car sales. To her anyway, crying was not a viable option. She explained, "If you break down and cry or show them that you're scared or weak or frightened of them, then it's just going to keep on more. They used to harass me, but I had to prove I wasn't intimidated by it. I had to toughen up." Thirty women said that "toughen up" is frequently men's advice to women. Yolanda described her experience with tears and the advice she got from her boss:

> There were times when working was real bad. For example, I remember I answered a phone-up and the gentleman on the phone wanted to buy a certain car we had up on the rack. It was pouring down rain that day. As a matter of fact, it was a

truck if I remember right, and I didn't know the size of the engine. I asked him to hold a moment and I would find out.

I went up to the podium where our trade vehicles were, the trade index on them, and the vehicle in question did not have the size of the engine. I think it had a V8, but it didn't put down 319 or 360. I asked my boss, who was sitting there, and his boss, the owner of the store, was across from me. I was still in question—I had been there maybe a month—as to whether they would keep me or not. And I asked him, I says, "This truck we have out on the rack out there, what size engine is it?" He says, "It is an 8." I says, "I know, but is it a 319 or 360? I have a gentleman on the phone who wants to know."

Immediately the owner called me a "dumb bitch" and told me if I wanted to know, to go out there and pull the thing down and look under the hood itself. And I went. I just kind of looked at it. I wanted to be hard and cold, because you have to be in this situation, in selling cars. But I found myself crying.

I told the gentleman on the phone I'd call him back. I went out. I climbed up that dumb thing. I pulled the car down and looked under the hood and called the gentleman back and put it back and I started crying again. I couldn't hold it any longer and sit at my desk without crying. I remember my boss coming over to me and saying, "Pull yourself together. You've got to toughen up. Why don't you go to lunch. Take an early lunch." He didn't want everyone to see me crying. I was embarrassed and tried to hide my face.

Women were told to "toughen up" even when the owner was a woman. Helen told her women agents to be "strong," to "humor" the men and "overlook it":

> I think they [men agents] feel if you can do a man's job, you can take the jokes. If anybody harassed them [women agents] a little bit at my dealership, I stepped in. I didn't talk to the guys; I just talked to the girls. I said, "Look, you're going to have to be a little bit stronger; you're going to have to be a little bit smarter. Just smile. I mean, that's a hard thing to do, but you just adjust. You've got to accept this."

Gina talked about this behavior as a way to test women's mettle in order to be qualified to be "one of the boys." She concluded that if a woman got a reputation as "tough," she would be accepted.[4] Learning to deal with harassment is part of what women need to know in the car sales community. Eventually, they learn to avoid certain situations and manipulate co-workers who cause those

with less experience to lose control. Literally, they become different people as they work out their responses.

Interacting with Co-Workers

Once they made the decision to stay, women started to look for alternative strategies or avenues of conduct and ways of behaving and interacting that would enhance their positions with men co-workers. Women managed their behavior so that it would fit men's preconceived ideas of what was appropriate for their sex category.[5] Some strategies were derived from past experience on other jobs and in their families. They brought men home-cooked food, sewed on shirt buttons, did men's paper work, and listened to co-workers' problems.[6]

"Sister"

Younger women sought the protection of "older brothers" against customers and men agents with improper intentions. Isabel pretended to be less intelligent and noncompetitive:

> I came in and they looked at me like, "I'm gonna kill this little broad." But eventually they liked me, despite themselves. It was like they were all my older brother. I love them all dearly. I think they look at me like a kid sister. Maybe it's sort of an act, where I just act like very bubbly and flighty and have a nice word for everyone because that way they don't feel intimidated. They feel when I sell that it comes naturally and they just sort of sit back and laugh. You know, it's amusing, I guess, to watch me work because I'm so crazy. If you deal with men in a tactful manner, not where you're threatening their masculinity by saying, "Hey! Bud, back off!" but just play little games like "Okay, la de da."

Fran attempted to gain more respect by listening to men's personal problems and giving them advice about their love lives. In return, the men were patronizing but discontinued their previous harassment:

> A couple of them are like brothers now. They come to me for advice with their love life. I think it's funny. I know that they're happy with me. They don't treat me like I'm one of the guys. They watch their mouths. There's a big difference. They are very careful about talking dirty or swearing or anything like that. They don't want me going out in the parking

lot at night alone. They don't ask me to move the cars around in the show room, where I did that at first. They like me. They respect me.

Older women gained even more respect by interacting like mothers or grandmothers.

"Mother"

Older women treated men as though they were children who sometimes behaved badly and needed care. When I first met Nina, she was sewing buttons on a man's shirt because she kept a sewing kit around and was allowed to do mending when things were slow. During my interview with Wendy's manager, John, she appeared at the door with a hot meal for him, and he called her "mom." Afterward he explained to me, "Wendy's just like that, a mother to us all. She worries that I don't eat well because I spend such long hours here. She's great!"

"Secretary"

Most women had to be superwomen. Being "superwoman" on a car lot meant doing more than the officially required work and doing it well. Superwomen attempted to make themselves invaluable to men co-workers. They took on additional unpaid work. Chris ran errands for other men sales agents and did secretarial work such as mailing out flyers:

> I've delivered cars for other salesmen that were out to lunch or somewhere. I don't mind doing it. I pull my load. When it was wintertime, I went out and moved the cars for the guys. Whenever it came time to do whatever, I was always there. If guys came to me because I had a lot of knowledge of other things and they'd ask me for help, I'd always help them out. I had a lot of car knowledge, a lot of model knowledge. Everything is in code. So I could find out what cars are at other dealerships because I knew how to work the computer and things and they didn't. I knew how to do dealer trades so they'd ask me, "Can you find this car for me?" To locate the cars and do the actual trades sometimes takes a day. They did not pay me for it, but I think they appreciate me here.

Newly hired women did not rebel at doing this extra work but considered it pulling their load or working harder in order to pay their dues into the fraternity

of car sales. They said it was easier for them because women were "more organized" or "better at detail work." Evelyn was proud to work harder:

> I work like a dog. I have more energy than most salesmen. I do all the detail stuff, too, like I do all the car ordering stuff. I'm going to make three times what I did as a teacher, and I won't have to moonlight at a second job the way I used to.

Some women sales agents, however, wanted to interact with men agents in the same way they (men) behaved toward each other.

"One of the Guys"

Barbara was allowed to stand around with the men. She swore, told dirty jokes, and "dished it back" when the men got on her nerves. However, she felt bad about behaving "unladylike":

> I am "one of the guys," really. They use profanity in front of me. Sometimes I have to hold back, because I do too. I want to be a "lady," and sometimes I am "one of the guys." And I don't like being that way, and my husband doesn't, either.

Barbara worried that if she swore too much in front of the men they would think she was not a "lady." So, becoming "one of the guys" required holding back. Although swearing had become natural for her, she had to control her behavior to convince the men that she swore only to fit in. They saw her occasional swearing as compatible with their behavior, but if she were to show them she actually swore regularly, she would not be acceptable to them. A few women, however, said that they did not have as many problems at their workplace because they dated co-workers.

"Girlfriend"

Through being a "girlfriend," women found acceptance, got help, and fit a social life into the long workday. In some cases this strategy worked well and a boyfriend became a protector, mentor, and supporter who helped his girlfriend gain acceptance into the work group and who warded off harassment. Ida had dated co-worker, Bill, for a year:

> For us it works real well. Originally our boss didn't like the idea, but we didn't tell anyone else for a long time and it worked out. We're always here; same hours, and we are to-

gether, so we see each other all the time. If I was dating some-
one outside the job, it wouldn't be as good because we
wouldn't have much time and I'd be tired when I got home.
On Sundays we get together with other men from the agency
and watch football and make videos. We're one big family.

However, many negative results may follow from this situation. The threat of
seductions, pursuits, rivalries, jealousies, and the intimacy of the couple threat-
ens group equilibrium (Lorber 1989). Women who dated people at their dealer-
ship were gossiped about by other salespersons and called a "sleaze."[7] Denise
said women who went out with men at their agencies gave women in the busi-
ness a bad reputation:

I think it's dumb to date people in your agency. What if you
don't like each other anymore? I care too much about myself
to set myself up with something like that. It's not healthy to
play where you work. People talk. That has been a problem
lately with Nancy [a woman at the agency] and what's going
on with Don. I hear she always sleeps with the guys where she
works. She won't be here much longer. I can tell. Besides, it's
women like her that give women in the business a bad name.

Thus, gendered interactions helped women cope but kept them on the periphery
of the groups. Women could not interact as individuals, different, but equally
acceptable members of the workforce. And, in this hostile environment women
began to develop sales techniques.

Beginning Sales Interactions

Miller (1964), in his classic ethnography of men in car sales, divides car sales
methods into four time sections: the "contact," the "pitch," the "close," and
"cooling." In each section there is a general pattern, or strategy, that salesper-
sons use to sell cars. Sales models such as the track system previously described
have been developed in relation to the amount of time deemed appropriate to
spend on customers and how this time should be managed in order to sell a car.
A problem arose here because women considered time in a way different from
men, and many attempted to divide it differently. Arguments between the
women and their bosses arose concerning who should define how much time
should be spent with individual customers and how that time should be spent.

The Contact: Rapport and Rejection

Sales agents usually took turns greeting walk-ins at the door. A few dealers, such as "green-pea" trackers, and "one-price" stores had designated "greeters" stationed at the door that waited for customers and led them to sales agents. At other dealerships, sales agents watched the door from their offices or on the floor and went directly up to customers. Some sales agents were required to take turns, while at other dealerships sales agents vied with one another to see who could get to the customer first. Usually, however, women had to approach the left-alone customers men did not want. In addition, in most cases, connecting with customers was more difficult for a woman than a man. Even in cases in which customers expected or wanted to be approached by a sales agent, they might not want that agent to be a woman. Thirty-five women sales agents remembered many first interactions as upsetting and negative. Arlene, an Hispanic woman, said that older men especially did not expect or want to be approached by a woman. They felt uncomfortable and were not used to bargaining with women over cars. They did not want to answer questions about their income or credit rating or even discuss cars with a woman:

> You can sense certain things. You see the older gentlemen that are, "What is she doing here? She doesn't have to know my business. She doesn't have to know how much I make a year, what bills I pay." When you are talking to them in regards to their credit history, they don't like it. I was helping this gentleman to do his financing on the vehicle and he made a wise-crack to me. He said, "Well, did you get your green card fixed?" All that does is to show me what he is really thinking.

Joan agreed that when approached, many older men reacted in a rude, insulting manner or openly refused to deal with women and asked for a man:

> When I started out I took a lot of guff from older guys. I got kicked in the face a lot. Men coming in and not wanting to talk to you. Men coming in the door say, "I'd rather talk to a man." Men thinking that I was a receptionist. "Would you get the salesman, please?"

Evelyn said some older men used foul language or were abrasive and newcomers ended up turning these customers over to men:

> I said, "Hi there, can I answer any questions for you?" An older man said, "No, I just want to see what kind of Jap shit-boxes you sell." Right away he was telling me, "Get outta my face!" This person was aggressive and insulting. I backed

right off. I turned him over. I went to the floor manager and
said, "This guy does not want me to help him. I can't handle
this guy." A man sold the guy two cars. The guy told him, "I
don't like broads."

Although twenty women said harassment most commonly came from older
men, four newcomers got rejected by wives who came in with their husbands.
Cathy moved from a dealership in a working-class suburb to one in an area with
wealthier clientele because of what she called women with a "blue-collar men-
tality" who believe that other women should not be selling cars:

Sometimes I have problems with wives. I'm a threat to them.
I've run into it twice in this store. At the other store it was
worse. They would literally walk away from me. They
wouldn't talk to me. Maybe they were jealous or afraid their
husbands would buy whatever I suggested. It was a blue-collar
area. They thought women's place was in the home.

On the other hand, thirty-five women said it was a positive attribute to be a
woman in car sales when providing special connections with business or career
women who buy their own cars. They said that "most women who come in
alone to buy a car feel vulnerable to hard-sell pitches from men." Ann recalled
that women expected abrasive sales agents who did not think women were seri-
ous customers or were able to make decisions without men. These customers
were thrilled to find women selling cars:

Often women were like, "Oh, God, I'm so relieved to see
there's another woman here, because when I was down the
street, it was awful. The man told me to come back with my
husband. I've been divorced for ten years, and I don't need his
decision."

Oprah believed this attitude was changing from surprise to expectation, and
many women depended on asking for and finding a woman sales agent:

When women walk into the showroom now, they are no
longer shocked to see a woman selling cars. Women are de-
lighted. I talk to them all the time about how much better they
feel coming in. They feel there is more common ground there
and they can relate better.

Other categories of customers preferred women as well. Arlene said sen-
iors preferred being approached by women, and so did young people buying
their first car or immigrants who had difficulty with English. Arlene believed
this was because she was gentle, patient, and understanding; thus, she was less

threatening to more vulnerable customers with lower incomes or less bargaining experience:

> I find that older couples like me. Especially Spanish-speaking ones. Also people buying their first car. They feel comfortable with me. I don't come on real harsh. I have never been a harsh person. I think sometimes people buy from me because they feel bad for me because I was so nice to them. I listen to them. I spend a lot of time with them. I figure, "What have I got to lose? Life is short." I translate for Spanish-speaking people. I come on very soft, and if I'm not going to be able to make money, I still treat people nice, because down the road, I might get some business later, where some of the men are very short-tempered. They won't spend the time.

Time was a major issue for women newcomers. They said they were willing to spend more of it in general. They claimed they were more patient and understanding and more concerned with referrals or repeaters. In the contact stage they were willing to spend an hour or more just talking with possible customers. They struggled with aggressive models that called for pinning customers down within the first five minutes or so.

The Pitch: Ignorance and Technical Knowledge

Various strategies were used by newcomer sales agents in order to be convincing; most involved methods for gaining trust.[8] In this way sales agents could control the sales situation. Some new women thought the way to succeed at this stage was to be knowledgeable about the product in order to convince customers their dealership was reputable and service-oriented. Leah said technical knowledge was the key to good selling techniques:

> I want to sit down with the guy who subscribes to any and every automotive magazine and talk to him from principles of engineering application, their origin, their point of apex change or modification. I don't just want to sell a car. I want to deal with the young kid out of school, the widow in transition. I want to sell them a technical piece of machinery, and I am responsible for their understanding how it operates. It's not just to get in the car and engage the engine. I sell a piece of equipment. I sell a mechanical object, a piece of machinery. I'm not interested on how much I make on this deal or whether or not you like the colors of what I have. I'm more interested in that you understand what you are purchasing and

spending your money on. Too many times a woman couldn't tell you where to change the oil. She wouldn't know what transmission fluid is or where it goes. She doesn't know the brakes are operated by brake fluid. And it's worth their while to never have to be at risk or liable to any individual because of lack of knowledge of something they own and operate.

Women entering car sales who were not as technically oriented as Leah said they wished they knew more about cars because if they lacked technical knowledge, men customers tended to use their lack of technical knowledge to intimidate them. Denise remembered the kinds of questions she was asked in her first month on the floor:

> Women aren't supposed to know a whole lot about cars, and they kind of played me off that way, even if they talked to me. If I tried to ask them questions, they would ask me questions, and they would test me more than men. They'd open the hood and ask me where the carburetor was. Well, the cars are fuel-injected, so there's no carburetor. They would ask, "How do you lift the engine on the van?" I just didn't know those things. A salesman at my dealership asked me, "How in the hell do you get in that kind of a conversation with somebody?"

By contrast, women felt they had an advantage when dealing with first-time women buyers, recent widows, or divorced women who seemed to trust them more. Many of these customers had relied on men for advice and information most of their lives and were glad to have the help of a woman. Even the pitch of new women agents with limited technical knowledge was appreciated by women buyers. Denise said women were glad to discuss their ignorance about cars with women in order to get help in choosing a car:

> My favorite of all my customers are women, especially middle-aged women, or women who just went through a divorce, or single women. I do very well with them They come to me for advice.

However, new women agents felt anxious over displaying technical knowledge about cars in order to prove their credibility to men customers. And, Harvey, who just started selling cars, felt technical knowledge was superfluous because sales agents could get help from co-workers:

> If there are customers that really want to know everything, I go to somebody that's really good with product knowledge. We have a couple guys here that know everything about it.

I'm good at selling. I am not afraid to ask somebody to help me out with a question I don't know the answer to. I just go to somebody else and they'll help me even though they are not going to get anything out of it now. Sooner or later, I'm going to help them. I guess they know that.

But most women were excluded from the male team and could not get help readily, so they were at a disadvantage once more.

The Close: Manager Assistance and Price

"Do you want to take this baby home tonight?" Despite one-price dealerships' claims to the contrary, this is the "close." The customer has chosen a car. Now, the sales agent presses for the monetary commitment–the deal that both buyer and management will accept (Miller 1964). The offer, if made, is then brought to management for approval. The sales agent puts on a show of taking the side of the buyer against management in the price negotiations to close the deal. Strategies here involve relationship issues on which a person who is working for the house adopts a mediating role where he or she bargains between the outsider and the house. Gender plays a minor, if any, role at this stage of the sale. Sales agents cannot afford to be openly hostile to customers because they will lose a sale, but they can be hostile to the house as long as they sell. Besides, as Pearl said, this strategy helps the customer believe that the sales agent is on his or her side against the house: "If management looks bad, that's okay, because it's you they're going to trust and it's you they're buying the car from."

Even if customers believe the middleman is on their side, however, this position is fraught with potential conflict. Sales agents lack control in brokerage relationships because the house is the party with the greatest financial investment in the dealings and holds final veto power over all transactions. When the house turns down an offer, the new sales agent loses credibility with the customer. This often happens because the house does not trust newcomers to put on a good enough act to make a high profit on the car so most newcomers are not told about actual costs. Managers say they think it is better for newcomers to be kept in the dark because then they will not be tempted to sell a car for less. Managers complain that new sales agents are apt to be sympathetic with customers. Managers say ignorance about real cost is easier on agents and simplifies their job.[9] Frank believed that an agent who was truly ignorant about how much profit the house was making on the deal he or she negotiated was more believable to the customer than one who had to cover up with lies:

> You try to keep your salespersons in the dark as far as costs on cars. They don't know how much they can sell these cars for, they have no idea. They don't know how much gross is in the

car. And they are believable because they believe what we tell
them. If you believe something and you try to convey it to
somebody, chances are they are going to believe you more
than if you give them a lie. Salesmen are not allowed to have
access because it works better for them that way. If the man-
ager tells them, "No, you can't sell that car for this amount,"
for whatever reason, "This is the price you got to sell it for,"
they go out there, and that is what they do.

Being distrusted by bosses as well as customers was often a new experi-
ence for women. New sales agents find themselves in an uneasy place between
customers and employers. Becoming a trusted member of the sales group for
newcomers meant placing themselves squarely on the side of the dealership. In
many situations, stores expect new sales agents to hand customers over to man-
agement once the customer makes an offer. According to Bernice, managers
handle negotiations this way:

The way they do it is the agent handles the customer. He picks
out a car. She gets the customer to make an offer. Then they
agree to a given price. Then the agent gets the manager, and
the manager goes back to the customer and tells the customer,
"All right, let's forget about this. This is what it really is. This
is what you are gonna pay for the car."

And, in situations in which managers allow new sales agents to close their own
deals, they have to go back and forth to the sales manager to announce what
they have been offered and see if it is acceptable. Bernice said customers did not
like being put in either situation. When the house turned down offers accepted
by the sales agent, customers lost faith in their agent. They wanted to believe
they had talked their agent down in price and that the agent was now on their
side and would talk management into accepting the amount they had offered,
which might not be the best possible deal for the dealership. If customers want
to feel that they are beating the house, they have to have confidence in the abil-
ity of their sales agent to be able to bargain realistically with the house and win.
Customers do not like to deal with sales agents who they think have no sway
with management. They want to trust that their agent is capable of getting them
the best price possible. It is thus logical to assume that customers will not trust
people who are not knowledgeable enough to stand up to the house and will not
want them as representatives. Barbara gave an example of a lost customer:

My first customer was a gentleman that found the car he
wanted and we go to sit down on negotiating the first price.
Management turned it down, and he bolted out the door. I
couldn't stop him. The problem was he didn't want to negoti-

ate with me. He didn't want to negotiate with someone who couldn't get him a good price.

Most dealerships fired sales agents if they let too many customers get away without closing, so at first newcomers like Barbara were willing to depend entirely on the manager to close deals. She said, "If it was not going well, I'd call a manager. Sometimes a new face means a difference. I'd learn about the price of the cars that way too." When new sales agents wanted to close their own deals, they tried to determine in advance how much they had to ask from customers to make the deal acceptable to management. Before firming a price, they made sure the house got a certain percentage of profit depending on how long the car had been on the lot (insurance was paid on each car for each day it sat) and what the car was taken in for. However, women made a point of saying that they also tried hard to satisfy customers who said they needed to pay the lowest possible price for a car. Leah, for example, was unwilling to talk customers into buying something overly high-priced. She said she could sell more cars by sacrificing her own commission and not pushing extras or add-ons. She felt that as long as the dealership was assured a base amount on each car, it should be satisfied:

> I'm not out to con. I'm out to make a living. I can sell a lot of cars if I sell them cheaper and my boss screams at me. We got into fights a couple of times. I would say, "Well, let's call it the McDonald Factory. I'll sell a whole bunch for you, but I'm not going to make a whole lot of money on any one of them because I just couldn't do that. I'm not going to sit there and try and hit somebody for $2,000 over the gross on the deal to pad my pocket or even the dealership's because I've got to shop with these people and live with them."

This, of course, was in conflict with management policy of making the most possible on each deal and keeping new sales agents in the dark so they did not have pangs of conscience about asking high prices. At most dealerships base commission is $50. That is, regardless of how much the sales agent sells the car for, the least amount the agent will receive in commission is $50. The average commission an experienced sales agent makes after extras are added is about $200. However, commissions can go as high as $2,000 depending on the make of car and the extras on it. New sales agents rarely make high commissions because they do not ask enough for the cars and do not push extras. This produces major conflict on the part of the new agent who is being socialized not simply to make the pitch and close but also to think about selling in specific ways. And some newcomers, especially women, resist. They say, "I am not going to do this to people. I am not going to con them. I am trustworthy." Yet, my data show that once newcomers become experienced and socialized into the job, they will say, "I'm a professional. I can do these things. That's what a sales agent does. I can ask for this money." The people who become "professional," do not just

learn what to do, they also learn an attitude. They learn a vocabulary of motives that becomes part of their reality. And the traditional newcomer's ideology is part of the baggage that must be discarded if they want to become true car sales agents.

Notes

1. Integration into a work culture depends upon people learning the boundaries of their social situations and appropriate responses to particular circumstances. See Patricia A. Roos, *Gender and Work* (New York: State University of New York Press, 1985) and Kathleen Gerson, *Hard Choices: How Women Decide About Work, Career, and Motherhood* (Berkeley, Calif.: University of California Press, 1985).

2. Occupational humor of this sort has significant consequences at the workplace. It is a coping mechanism and morale builder that sustains workers through periods of boredom and helps men to deal with low-status jobs. See Marvin R. Koller, *Humor and Society: Explorations in the Sociology of Humor* (Houston: Cap and Gown Press, 1988). It is not only low-status men in sales work who torment incoming women. As many studies clearly show, professional and executive women also confront men's humorous harassment. See Rose Coser, "Laughter Among Colleagues," *Psychiatry* 23 (1960): 81-85. Coser describes similar behavior at academic faculty meetings she attended. And, Kanter (1977) found that males in the corporate world were always asserting their group solidarity by relating their sexual adventures and telling sex jokes.

3. Crying is known as a traditional female response to problems such as harassment. It is a way to deal with a situation over which one has little control. It may be a response women have used before in other situations. This strategy, however, validates men's power and leaves them in control. Goffman places crying in an "out of play" category because it is an inappropriate reaction in the work place. He says if workers lost control, most times it would increase the tension level and bring about further unwanted incidents. See Erving Goffman, *Encounters* (Indianapolis: Bobbs Merrill Company, 1961). Inexperienced waitresses were found to cry from nervous tension when they could not keep up with customers' demands. See William Foote Whyte, *Men at Work* (Homewood, Ill.: Dorsey Press, Inc., 1961).

4. Rustad (1984) describes a similar process in the army where women are evaluated on their emotional control under harassment.

5. For a theory on accomplishing situated gender difference, see Candace West and Sarah Fenstermaker, "Doing Difference," *Gender and Society* 9 (1) (February 1995): 8-37; and Candace West and Don H. Zimmerman, "Doing Gender," *Gender and Society*. 1 (2) (June 1987): 125-151. For examples of work situations where women "do gender," see Kanter (1977); Rustad (1984); and more recently Susan Ehrlich Martin and Nancy C. Jurik, *Doing Justice, Doing Gender: Women in Law and Criminal Justice Occupations* (Thousand Oaks, Calif.: Sage Publications, 1996) and Rita Mae Kelly, "Sex-Role Spillover: Personal Familial and Organizational Roles," in Dana Dunn, ed., *Workplace/Women's Place* (Los Angeles, Calif.: Roxbury Publishing, 1997) 150-160.

6. This is similar to office "wives" who ran personal errands such as getting birthday presents for their boss's family members described by Kanter (1977). For theoretical explanations of this behavior, see Nancy Chodorow, *The Reproduction of Mothering* (Berkeley: University of California Press, 1978).

7. This is similar to the reputations earned by "Rustad's (1984) military women as "Sex Pots" who formed relationships with supervisors and were considered whores.

8. Goffman (1959) claims the social interaction involved in this type of endeavor is similar to a theatrical performance. Miller (1964) says the successful sales agent puts on a better show than the competition—especially the other sales agents on the lot.

9. Hughes (1971) found real estate sales agents who had to defer to the realty house and nurses who had to take orders from doctors regarding patient care had similar problems. Browne (1973) found car sales agents' conflicts were intensified in this type of broker arrangement, because they had an unusual degree of ignorance concerning issues crucial to their dealings. They did not know what the dealership had originally paid for the car or what they were willing to accept for the car from the customer.

5

TOUGHENED UP:
EVERYDAY LIFE ON THE FLOOR

I remember falling in a hole. We were walking on snow and I was
talking to a customer and the lot was being renovated and the next
thing I know, I was in a hole and the customer is standing up there.
The man didn't buy a car. The guy probably had no right to be on the
lot. He was bankrupt. Yet, you have to treat these people just as nice
as everybody else. Sometimes you close on a deal and find out they
couldn't buy a car if they wanted to.

–Jean, *ten-year car sales veteran*

As women grew in their awareness of the instability of the business, their fear
and distrust of other sales agents (usually men because there were few women),
as well as customers, grew as well. Themes related to co-worker distrust wove
throughout the structure of car sales, both within informants' own agencies and
across other dealerships. As previously discussed, there is a very high turnover
in this field, and few employees stay long at any one dealership. Because dealer-
ships come and go and the popularity of makes of cars is erratic, workers move
with the flow. For many experienced women, acceptance by or cooperation
from co-workers became relatively unimportant. While at first they felt a need
for a support group, later their major concern was how to deal with other sales
agents' dishonesty.[1] Women agents who were not allowed into the men's team
at dealerships distanced themselves from the group of men agents by proclaim-
ing their difference. Jean said men could not be trusted to compete fairly:

I play fair. A lot of guys don't play fair. Some men hold their
numbers of cars sold in their offices and don't put them on the
board until the last minute or the end of the month, so some-
one can think they are winning all along and then at the last
minute find out someone else did more selling than they did.

That's underhanded. We get prizes and bonuses for the most sales and I look forward to that.

Vita said men co-workers cheated and lied in order to steal each other's customers:

> Salesmen do what is called "skating," where they steal someone else's customer. Like if you had a customer that came in early for an appointment and a salesman would sell them the car and say, "Well, she's not here today, but I'll sell you the car and see that she's taken care of." But, they never did it. If they get caught, they send them home for a couple days. That takes two or three days off the floor, and when you're working on commission, that hurts.

Keeping a Distance From Co-Workers

Experienced women such as Betsy and Jean steered clear of all men agents. They kept interactions on a superficial level because they feared they had more to lose than to gain from co-worker relations in which they had no basis for trust.[2] Betsy complained that befriending newcomers makes trouble for an experienced agent:

> Newcomers can drag you down. Most are "floaters" who are not conscientious. They come in late, take days off, work a while and then quit. If you try to help them, they will steal your customers or get you in trouble with management.

Jean kept her distance from newcomers so that they could not know her business or gossip about her:

> Many of them are starting out. Some of them never make it to the point where I am. To be with a dealership this long is unusual. I have to be one step ahead. I have to carry myself aloof. I don't have to be on their level. If I'm a little beneath the customer, that's okay, but not my co-workers. If I communicate and talk with them and be their buddy, I can lose everything. They will try and cheat me. They could gossip about me. They are not to be trusted. I'll say, "How are you?" I'll talk pleasantly. That's nice to a degree, but I'm like a horse with blinders on. I go in, I do my job, and I go out. That's it. I need cooperation from management, not from my co-workers.

Jean distrusted co-workers and management but said she needed cooperation from management. If experienced agents spend too much time helping new-comers, they may be endangering their own position. Newcomers may sell more than they do and thus replace them, or they may turn out to be untrustworthy, lie to management about them, or steal their customers. Experienced agents could not afford to take risks in the competitive, unstable field in which they worked. Women were especially vulnerable because they are marginal members in an unstable field. They were trying to support themselves and could be fired at any time. Their stability depended on meeting high quotas. Thus as women became increasingly socialized into the business they put their energies into developing methods of sales that worked for them and did not concern themselves with making friends of co-workers.

Sales Techniques

When experienced women agents described their selling techniques a pattern emerged that differentiated women's styles from men's. Most experienced women continued to use the same techniques with which they began: (1) they approached customers more slowly, often spending time with those who ap-peared to be just browsing and did not "qualify" customers according to their suspected buying potential; and (2) they tended to use a relational method of selling that dispensed with high pressure. But now they were more distrustful of customers. They eventually believed the way men agents did, but tried to make customers believe they felt differently.

The Contact

I'm Not Choosy; Everybody's a Customer
Management liked to keep women at a disadvantage. Men blocked them at the door and managers stationed them at a safe distance from the expensive models. Being at a disadvantage, women developed approaches compatible with their disadvantages. In many situations, women invented unique ways of approaching walk-ins that men did not bother with, giving them the option of "just getting a brochure or looking over the cars" so they would not think them too aggressive. Marsha, for example, pretended to be just passing by:

> I walk by the customer, but I'm doing something else, like pa-per work or checking on service, and I use this to make it look like, "Incidentally, may I help you?" That's the way I'm com-fortable, and I feel like, hopefully, they won't feel like I'm pressuring them. I probably won't talk to as many walk-ins as

other salespeople might, but I get good results with the ones I do talk to.

Dorene sidled up to customers, giving them the option to enlist or reject her help. This approach gave the customer more control over the sales interaction and made for better customer relations. Most women were similarly non-aggressive when qualifying the customer. "Qualifying the customer" means that the sales agent decides who is really going to buy and who is not. This process of qualifying entails aggressive verbal questioning as well as observation of a customer's behavior. The agent is expected to determine (1) how badly the customer needs a new car (will he or she buy today if the car is on the lot?); (2) if the customer has already shopped around at different lots and knows what is available, and what he or she wants (not just looking); and (3) how much money the customer can spend, and how good his or her credit is. It is not easy to learn these facts quickly without using direct questions that may alienate would-be buyers. But not having these facts may mean spending time with persons who are not really ready to buy. Losing a walk-in one has spent a lot of time with makes the agent look bad to management. So, men agents avoid customers who do not quickly qualify as real buyers according to their standards.

Most women said they could not qualify customers quickly, because they could not compete at the door to get "enough first-time buyers" to be "choosy" with whom they spent time. Also, because of the limited acceptance they got from many customers, women felt they, rather than the shopper, had to bear the burden of proving themselves qualified. Nora could not be a forceful questioner because that would scare even more men away. Nora said she treated all customers as serious buyers:

> Buying a car is a horrid job for most people. People who come in here are upset and confused. Most people who come in here are defensive. They want a car, but they don't. Some people will walk in, and they want one thing, but can't afford it. They have probably been given a bad time by other salesmen. I do not give walk-ins a bad time. They are already skittish. So you have to take time to listen to what they have to say. You have to get to know people. Then, even lookers will usually buy from you.

June said her past interactions with parents of students as well as her own behavior made her treat all shoppers as potential customers:

> Sometimes, the most shabbily dressed parents were doctors or lawyers. When I go shopping on my own days off, I am usually also shabbily dressed.

In contrast, men often tried to weed out those shoppers not immediately receptive to their more direct approach. The men I observed used "key questions" such as "If I got you the car you want, would you buy it today?" They also observed walk-in customers' dress and behavior to help them decide whether to spend time with these potential buyers. Most of the men agents I interviewed prided themselves on their abilities to make quick assessments based on these clues. They believed that "women who came in alone" were probably not ready to buy. They agreed that "the type of clothes" shoppers wore showed who were the "more likely" customers. Experienced car men told me they did not waste time with "tire kickers," persons who were just beginning to look and did not know what they could afford or what they wanted. Managers reinforced this policy even when the store was not "big numbers." "You've got to qualify the customer. I've seen a salesman spend an hour and a half with someone just browsing while his wife is grocery shopping. That's a waste of time. His time should be more productive" (Prus 1989a:83).

But, whether it has any validity–that is, whether the discrimination engendered by interpreting "clues" actually leads to higher productivity–is questionable.[3] Women agents were at odds with the male tradition of qualifying customers. They contended that the process as practiced is too uncertain and arbitrary, as many valid customers are likely to be lost through the assumption that they are "tire kickers." And, in any case, customers are alienated by it. Rather, experienced women put their efforts into inducing whatever customer they had to buy. But women agents could not use as hard a sales pitch as men. They could not pit themselves against customers in win-or-lose situations. Pushing the buyer too much was interpreted by men and women customers as rude, "bitchy" behavior that could lose the sale. Women said if they came on too strong, men just "walked away" or "asked for a salesman." Women said they needed to move slowly to convince men customers to trust them enough to discuss what they could really afford (i.e., the financial qualifications of the customer). Once they felt the customer trusted them enough to spend time with them, experienced women threw themselves full force into gendered interactions they had devised to sell themselves.

The Pitch

Let's Play (Soft) Ball
Pitches are methods of coercion used by car sales agents to push would be customers closer to becoming purchasers. The methods used by women car sales agents were not aggressive. They ranged from feigned innocence and ignorance about the cars they sold to relational skills such as nurturance and empathy. Probably because the first high commission sale made by most newcomers was painless and negotiated in ignorance, many experienced women continued to pretend they were innocent newcomers when making their pitch.

"Innocents"

"Innocents" never used crude language or insider argot. Roberta, a younger woman, looked and dressed like a college student:

> I've got a baby face, and I do not pose a threat to anybody
> who walks in—young, old, seasoned buyer, first timer. I put
> people at ease. I don't scare anybody. I've sold many campers
> wearing sweats with sorority letters on the bottom. I have a
> face that will show people I'm honest.

Innocents adapted through avoidance or feigned ignorance. They wore blinders so they did not see the dubious dealings going on around them and could deny being a party to the transactions. The woman who sold me my most recent car exemplified this orientation. She originally described the car as having been a manufacturer representative's car, a "brass hat." A week after I purchased the car, I dropped my pen and was feeling around underneath the front seat when I felt a small plastic object. This turned out to be a key chain from a car rental agency in Florida. It had my car's identification number on it. I called the rental agency and they verified that the car had indeed been theirs but they had recently sold it to Mazda. I do not think I would have bought this car if I had known it was previously used as a rental car. When I confronted Phyllis with the key chain, she replied:

> Is that true? I never asked too many question. I know I saw
> literature on the car ... that it came from an auction. I know
> they buy when Mazda is having auctions. I thought it was a
> manufacturer rep's car.

Other experienced women in my study told me when sales were slow, they "dummy up" (use ignorance and innocence to sell cars) because customers believed that newcomers did not possess the ability to devise ways of cheating them.[4]

Experienced women also used ignorance about technical matters as a pitch strategy. Laurie said she did not need to know a lot about the automobiles she was selling because that ignorance made her trustworthy and believable:

> Customers will think you are too innocent to cheat or lie to
> them and they will trust you more. The way I got by at first
> was because I said, "I'm new here." This was true. I knew
> nothing about cars. When business is slow, I sometimes still
> play dumb.

Another strategy Innocents used was to know less about the car than the customer. Norine said many customers then sold themselves:

Volkswagen customers are very educated about the car. They
have already researched everything. All you have to do is lis-
ten to them. They are going to sell themselves. They already
know the car. They like to show how much they know. So I
play dumb and listen to them.

As they progressed on their career paths, most women who wished to keep
both their jobs and the excitement they felt in their work continued to change
their values and attitudes toward selling. They lost concern with knowing the
mechanics of the cars they sold. A former teacher who previously valued ex-
panding her subject-matter knowledge said she no longer attempted to apply
similar values to product knowledge. Eventually, the desire to learn how the
automobile worked was replaced by learning how to sell oneself. Sally agreed
with Laurie and expressed her new concern. She said, "I used to worry that I
didn't know enough about cars, but customers know more about the mechanics
than I do. Most sell themselves on the car. All you have to do is sell yourself to
the customer." And, in order to sell themselves and coerce customers into buy-
ing cars, other experienced women made tools of their personalities and "femi-
nine" traits, using relational skills similar to those previously used with co-
workers. These women became "Ladies" once again.

"Ladies"

"Ladies" differed from "Innocents" because they claimed to be more knowl-
edgeable than their bosses about the way work should be done. They wanted
more autonomy over their work. The Ladies' greatest conflict with management
was over sales strategy. They did not want to play innocent or to use the aggres-
sive interactions of men's sales models presented to them. These women con-
sidered customers "unruly" yet "fearful" and "distrusting," similar to undisci-
plined, bothersome children. They spoke about them with an underlying tone of
warmth and endearment, implying that these misguided souls could be con-
verted or rehabilitated with the proper counseling or guidance. Ladies said cus-
tomers were more easily manipulated through forms of "feminine" behavior
than through aggressive "push" tactics. They cajoled and nurtured men custom-
ers in order to gain their trust. Ann said, "I tell them, 'Look at these pictures on
my desk. I am a mother. I am a grandmother. I wouldn't hurt you now, would
I?'" Renita helped customers feel comfortable, served them coffee, listened
with apparent interest to their problems, and generally treated them with familiar
warmth and hospitality:

You have to be nice and talk to them [customers] and make
them feel at home before you can sell them a car. It is usually
easier to sell a car if you establish rapport. This guy and I got
to talking, and he said something about playing the accordion,

and we established a great rapport because I play the accordion. He still drops in to see me every now and then.

Sally described her relational strategy, "I serve customers coffee and listen to their stories. I tell them stuff about myself if they ask–like if I have kids, and what kind of car I drive. Sometimes they tell me their problems." Ladies' sales techniques were performed in a way that did not build a hostile atmosphere between customer and sales agent. Renita explained:

> I am like a chameleon. I can relate to a truck driver, to the attorney, to ma and pa that come in here, to young people, to old people. This takes a lot of time and patience. You have to really listen. You have to change. You be what they want you to be. I had a band of gypsies. I put a scarf on my head. I said, "I'm going to put beads on. Oh, my, give me my crystal ball." We laughed. We had a great time. They bought two cars.

As just discussed, women's interactions tended to be dramaturgic and "feminine." Yet, some men's interactions with customers were not outside of the typologies presented. A few younger sales agents behaved like Innocents, or even like "Mr. Nice Guy," which I found comparable to that of the Ladies. My principal observation, however, was that these men worked at one-price or green-pea stores and eventually moved or left the business. Most men who remained in the field eventually became "Tough Guys." This was a role representing the behavior expected of men agents by their peers. It seemed to be a natural consequence in the heat of the sales arena for men eventually to become "hard-boiled." Unlike women, who would cultivate innocence, men wanted to shed any such appellation as soon as possible. Experienced men believed customers wanted them to use hard sales methods. They said customers anticipated "sparring" with them and came prepared with "blue book prices and consumer guides" for just that purpose. Men generally emulated the methods found in sales literature, which encouraged combative manipulative tactics to negotiate sales: "If a prospect says he's not interested, he expects the salesperson to tell him why he should be. The tug-of-war begins. Prospect says no, salesperson says yes–back and forth–until one side gives up" (Roth and Alexander 1983:107). This literature chastises sales agents who let buyers get away because the agent did not push hard enough:

> If you'd [the agents] had the courage to push, they'd [the customers] have given up the order. But you let up a little on the selling pressure, and they escaped. It's difficult for a customer to say no to a salesperson who pushes hard for an order. (Roth and Alexander 1983:39)

Control through pressure has been the tradition of a sales culture for men. At a typical car agency I visited, experienced men agents cast customers as "villains" or "enemies" with whom sales were closed by methods described as "holding 'em down" and "putting 'em away." Typically, the men I interviewed bragged about controlling customers through intimidation. Jim said:

> I listen to what "pushes their hot buttons" [what models, extras, and options excited customers] in order to "hype them up" to buy a more expensive product. Then, I pressure them into buying. I tell them, "It's the last car like it left, and it will go quick." Or, "It's such a great deal because it's the end of the month, and I need to make my quota, but I'm losing money on it and might change my mind."

George explained his aim to get customers into a "loaded car" (one with lots of extras) and "drag them screaming across the finish line" (close the deal against any customer objections). He said, "People will buy under pressure. They feel intimidated. I have the 'killer instinct.' Competitiveness. Just about every guy here now has it. We're in this business to make money."

Yet, it was the training material, the bosses, and the desire to make money that motivated the men to use aggressive sales tactics. It was considered the "masculine" thing to do.[5] Some newer men I spoke with said they wanted to "let customers go easier" but were shamed by co-workers for these feelings. They were called "wimps," "losers," and "wussies." This is also a sexuality issue similar to calling aggressive women "dykes."

In contrast, with these women's softer approaches, customers did not feel the sales push as strongly as in a situation controlled by men.[6] Ladies felt changing the interactions between customers and sales agents made the sales experience more humane. Ladies who were successful presented new, more gentle role models to men. By setting an example of success with less aggression, they countered the paradigm of the time. Those women who became aware that change was possible and sought it directly may be models of what all sales will be like in the future. Other Ladies attempted to find an ecological niche where there was less pressure for quick sales. Some moved to less competitive, smaller-volume suburban dealerships, "country clubs" that were more amiable or compatible with their lower-key style. And as previously stated, more women are hired at Saturn stores than at other dealerships. Certainly one-price and Saturn stores claim their dealerships are hassle-free. However, this style is also problematic for women agents. Straight salary is not as lucrative as commission work. At traditional dealerships, if sales agents spent time with too many persons who left without buying a car, their jobs were in jeopardy. Therefore, most experienced women agents who wanted to make a better than average wage needed to be able to close their own deals at a high profit. This was most evident when experienced women talked about closing sales. It was at this stage that

successful women agents' philosophy of sales agreed with the philosophy expressed by successful men agents.

The Close

Profit Motives and Games (Wo) Manship

Experienced women agents believed that selling at a high margin was rational and a measure of their success. Dorene said selling cars at the highest profit is just a game:

> It is fun to make a big commission. We trade stories with other salespeople about who made the most on a deal that week. You can't be in business if you don't make money. And making money is the name of the game.

Fran explained how she played this game by cheating and lying:

> Once you get them where they like you and they like the car, the price isn't that hard. If they come up with a low offer, you just say, "Let me talk to management." But really, the only time I go into management is to kill time before I let the customer know what price I'm gonna tell 'em. That makes 'em think I'm on their side. I should be able to make big bucks.

Women who reached this stage and style of selling were aggressive sales agents, with an easy-going veneer. They bragged about their abilities to close sales by beating men at their own game. I labeled them "Tough Ladies."

"Tough Ladies"

Denise called her style of closing "attacking nicely":

> My attitude is let 'em come in, let 'em look around. Let 'em feel comfortable, and then attack, but attack nicely. Keep telling them why they should buy the car. Don't let 'em get away. Be very calm and easy-going about it. If you attack and you show them you just want to sell them an expensive car, you send them away.

And even though experienced women used tact and did not directly war with customers, they put customers in an "out-group" as "untrustworthy persons" who are to blame for causing the dishonesty and animosity in car sales. Carol said customers were liars:

Some customers really want our vehicle, but they come here to see if they can rip you off, and they will. They lie about the condition of their trade-ins. They bring a car that they just brought to the repair shop and the mechanic said it was going to cost $700 to fix the damage. That's why they want to trade it in. They lie about their credit ratings, and they say they can get cars at other dealerships for less. The people who come in here can afford bucks. Probably, the more money they have, the harder it is to get it away from them.

Experienced women valued most what the customer gave them, not what they could do for the customer. Ann defined a "good" customer as one who gave her lots of money and a "bad" customer as one who tried to bargain:

We have wonderful people like Mr. Smith. What a wonderful guy. He brought his wife with him. She picked out the car. They added every accessory on it imaginable. The first price that I gave him he bought the car at. So the dealership made millions of dollars on it, and I made millions of dollars on it. But other people are always trying to chew you down. They're whiners, complainers. They deserve nothing and wouldn't be happy under any circumstance.

Yet, even when experienced Tough Ladies sold at high-volume dealerships, blamed the customer for dishonesty in the business, sold more aggressively, and distanced themselves from concern for customer needs, men co-workers felt women agents ("Tough Ladies") were not equal to men ("Tough Guys") in their competitive attitudes. Vic, a sales manager, said:

The women, they're more laid back. They don't have what it takes, the "killer instinct." People will buy under pressure. They feel intimidated. I have the killer instinct. My first four months I was here every day, twelve hours a day, because I didn't want to miss anything. I wanted to have the most numbers. I just wanted to win. I wanted to be on top, to get every walk-in. Competitiveness. Just about every guy here now has it. They hate to lose.

Vic was so competitive that he did not consider the customer's needs at all, even when he was a customer. He was angry that he was asked to pay too little for his own car, even though he could not have known exactly what the dealership made on him:

I went to another dealer to buy a car for my family. Because I
am in the business, I was willing to pay a certain amount over
cost, and without them even trying to make money off of me,
because considering I'm in the business. We're in this busi-
ness to make money and they didn't try to make money on
me. Bad manager. I wouldn't want to have a manager like
that. I wouldn't want him managing my store if he is weak,
that easy. They built no value in the vehicle [added no extra
options] and they had the list price dropped down to a $200
deal.

When I repeated the story to Patsy, a profit-motivated experienced sales
agent, she explained:

That guy is brainwashed. He would sell his mother to make a
profit for the dealership. He has gone over the deep end. But
people change in this business, even women.

Patsy then told me about a divorced woman, Karen, who was training for the
position of general manager at a nearby dealership and gave up custody of her
children in order to work longer hours. I did, in fact, interview Karen, who ex-
plained her situation:

I am being trained for general manager. This is unheard of for
women in this field. I have to spend all my time here [at the
dealership]. I used to cook, clean, take care of my family, and
work. Now that the kids live with his mother, I eat out, and I
don't clean. I see them on Sundays. I don't remember the last
time I cooked. I'm here most of the time. My boss says I'm
the most dedicated person here.

Thus we see a clear picture of the positive changes women make in automotive
sales as well as the negative changes that automotive sales makes in women's
values and attitudes as they progress from novices to experienced sales agents.
Customers do not like to be beat-up when they buy a car. They appreciate
women's gentler handling and softer words. They even believe women are more
honest. On the other hand, management does not allow women to be more hon-
est or give better deals. Management encourages women to block their feelings,
interact in a "feminine" yet "masculine" manner and lie to customers as well as
to themselves. Management tells women that service work is a game and if they
play the game right they will make enough money to live the good life. In their
desire to reach this goal women blame customers for holding out money and
interfering with their future plans. The car business plays havoc with women's
beliefs and views of the world, and this is reflected in their personal lives.

Notes

1. Goffman (1961) suggests people attached to a role they are unable to embrace fully may accept the situation but then withdraw by some symbolic gesture or other.

2. In organizations in which each individual is isolated yet connected to a common base, there is a characteristic distrust reaching horizontally as well as vertically. Usually in a workplace, at least according to classic Marxist theory, the antagonism between employers and workers encourages the workers to bond together and develop a shared understanding of their situation and an awareness that they have a common enemy, the employer. But the common enemy here is the fellow co-worker as well as the employer. These perceptions and beliefs about co-workers help explain the persistence of distrust and fear in a lot of commission sales work.

3. Robert Rothman, *Working: Sociological Perspectives* (Englewood Cliffs, N.J., Prentice Hall, 1987:166) has argued that there are "no firm rules for making a distinction between non-buyers and buyers."

4. Goffman says the custom of "playing dumb" leads to "a special kind of alienation from self and a special kind of wariness of others." Discussing the dilemmas facing young American girls in the 1950s his respondent says, "Sometimes I play dumb on dates but it leaves a bad taste. The emotions are complicated. Part of me enjoys putting something over on the unsuspecting dude. But this sense of superiority over him is mixed with feelings of guilt ... What am I doing here with him anyhow? Slumming? ... The girl's performance of 'young American middle-class girl' can not be distinguished from her sense of herself" (1959:236). See Hughes (1962), Mills (1951), and Hochschild (1983) for theories on how and why persons distance themselves from potential disloyalty to others in a relationship.

5. Leidner similarly found that insurance trainees and agents "framed interactions with customers as contests of will requiring aggression and domination" (1991:166-167).

6. Studies by Lundstrom and Ashworth (1983) and Rey (1986) find that these types of gendered interactions do influence customers to believe women are more trustworthy as car sales agents.

PART THREE
OFF THE LOT

6

ON AND OFF THE FLOOR:

FINDING A BALANCE

Wendy is divorced and she wants to hang out with the salesmen and go out to drink after work. I told her, "No way!" That's a big thing in this business. It is very common, going out after work and having a drink and everybody runs around with everybody else. There's a lot of divorce. This business is notorious for that. Women who go to the bars with the guys are very popular because there are few women. But women who do this are not very well liked by salesmen or management. They usually get fired.

 –John, *Wendy's general manager*

There are additional contradictions for women over and above those of the sales process. These are in the areas of social and family life. Car sales is an occupations in which hours are not flexible, and the structure of the job does not take the worker's personal life into account. Workers get Sunday and one weekday off each week, but most stores are open late every night except Saturday, and workers put in "bust out" days of twelve hours or more. This leaves few hours for social or family life outside of work. Women who choose to sell cars must put most of their time into the workplace if they are to make a living and succeed Some of the women sales agents in my study are successful according to many men's definition of success.[1] Their lives are solidly middle class. They own their own homes and are established in a line of work. But, there are many major differences in their attitudes and behavior toward work, family, and social life from that of men. As lifestyle alternatives open to them have become more varied and complex, especially regarding the choice of work and family roles, the number of crucial decisions women face has increased. Under these conditions, women struggle with the kinds of family and social life they want to have as well as the kinds of persons they want to be and what they have to settle for.[2] Many women in car sales settle for no social life whatsoever.

Dating

The single women in my study said they did not go out with men very often. They did not have the time or opportunity to meet men, and men did not like their hours. Evelyn did not date:

> I don't date. Nobody asks me out. I don't go anywhere to meet anybody and I sometimes wish I could. Everybody's lonely sometimes, but right now it's like I'm too busy to be lonely. A lot of people are worried about me. They say, "What are you going to do when you're a thousand years old and there's nobody to talk to?" But the hours I work, I really have to say I give 100 percent to my job. When I make enough money, then maybe I'll date.

Dorene, who got divorced during her car sales job, concluded that if she had started out single, she probably would have remained that way: "If you're single in the car business and you're trying to date, there's no time. Your social life, it's sort of not there." Edith described a "perfect evening" as one where she hung out at home with a girlfriend and drank:

> You have a real hard day and you're in a bad mood and you don't want to go anywhere and have to make small talk. A girlfriend sells cars at another dealership and we've become real close. On Saturday night we were supposed to go to Ravinia [an outdoor music festival] and we sat there and we looked at each other and it's like, "Oh, no!" We picked up a bottle of wine and went over to her house and just sat there and did nothing, just drank.

Jean watched TV alone:

> I love to go home and not have to make dinner for somebody else, or "be up" for somebody else. If I want to go home and just lay on the couch and watch TV, with the hours I work, I need to do that, to sit and not talk to anybody.

Denise even gave up her girlfriends for work:

> I really hate to schedule anything for my time because it is so valuable. It's hard to psyche yourself up to go out on a date or go to a movie. I fall asleep. A lot of my friends have suffered. I used to be a very social person. I need some space. I need time away from people.

Nora, thirty-five and single was still living with her parents:

> I'd like to take vacations, but I never have time. When I make
> more, then there'll be time. Right now I have to live with my
> parents because I don't even have the strength to make myself
> dinner or go out and find an apartment.

In order to meet and date men, some women went with people in the car
sales business. Fran's ex-husband was in the business as was her current boy-
friend. She said, "I came in single and I married another person in the car busi-
ness. We got divorced. My new boyfriend is in the car business. I never have
time to meet anyone else." Ida, twenty-eight and single, pointed out it was the
only way she could have a relationship under the conditions of her work:

> My boyfriend is in the business. He works at this dealership.
> You have to have a boyfriend in the business. I've had other
> boyfriends before and it didn't work out because of the hours
> and the fact that you're extremely independent. It's hard on a
> relationship if they [boyfriends] don't understand. If you're
> doing the same thing the other person is you don't feel as if
> you're missing out on something. You spend most of your
> waking hours with these people that you're working with. My
> boss was worried about it. I kept telling him to "stick it up his
> ass" because he was bothering me and there was no reason for
> his concern. I said, "You've got nothing to worry about. It
> doesn't interfere with my work. It never has, never will. I can
> handle it. Our relationship is stable."

But other women agents said relationships with men sales agents were not
stable. Renita, forty, blamed the business for her first divorce, because the long
hours and stress "played havoc" with her family life:

> Marriages are very short lived in this business. I think the
> hours have something to do with the fact that marriages don't
> have longevity. My first marriage only lasted a year. My first
> husband was a service manager and his hours were shorter
> than mine. When I would come home late he would get upset.
> My second husband is a sales manager and he had my job at
> one point. He knows if he calls here and they page me and
> they can't reach me that I'm busy. He understands the busi-
> ness. And, my kids are grown now, so they don't need me. So
> I think we have a better chance. But I still worry.

Dating people in the business was a way to form relationships, but hardly a guarantee for any real stability. Women were open and reflective about their failed marriages, but continued to repeat their actions, adjusting their perceptions and making things look better than they were. They dated men in the business and married other men in the business. And, each time they hoped that this time it would work. Although the single men also got fed up with the hours, Pete said single and many married men had a social life of sorts, which consisted of going to local bars after work and rehashing the day.[3] Harvey said:

> What you'll find in the business, because of the hours, is a lot
> of individuals that are not married or that their marriage is not
> real important to them, so there is a big social thing after work
> for a lot of people. They go to bars.

Thus, men found ways to negotiate and deal with the system that women could not do. Single and some married men spent evenings in bars without concern over stigma or being fired. And men socialized with each other on the lots during slow times. Social life was not the only aspect of private life affected by the business. Informants said they had little time or energy for much of anything else.

Chores

Women, married and single, with and without children, altered their approach to household chores because of their sales work. On her days off, Norine was too tired to do the chores. She said, "For a while there when we [the dealership] were short handed, the only day I had off was Sunday. I spent the whole day sleeping, trying to catch up from the week before." Marsha became less concerned with others' opinions about the cleanliness of her home:

> During the week there is no time for the house. By the time
> you get home it's 10 o'clock. Who wants to do anything then?
> I've gotten to the point where if my house is dirty and some-
> body comes over, if they don't understand, that's their prob-
> lem. It's not a number one priority anymore where it used to
> be years ago. I'm not embarrassed anymore. You get used to
> it.

Dorene stopped cooking for other people as well as herself, and complained about her poor diet:

> I have stopped cooking. I cooked for ten years in my mar-
> riage. Then I lived with a man for two years and I cooked for

those two years and the last two I really haven't cooked. You eat out. I eat lunch here and that's about it. I don't have time to cook. I eat out mostly. My diet is potato chips and milk. I have a terrible diet.

Marsha, divorced and middle-aged, finally bought her "dream house." Still, she spoke about quitting in order to have a social life, cook, sew clothes, and garden:

> I bought a large house for Denise [daughter] and me. I wanted to be able to pay off my mortgage and find other work. I always wanted time to sew my own clothes or garden. I wanted to have a social life. But I don't make enough money and I don't know what else to do. Maybe things will get better and then I'll have more time.

As broader national statistics attest, fast-food restaurants now provide a good number of meals that women once cooked at home. Working women cook less, clean less, and spend less times with family activities in general.[4]

Family Life

I had expected to find mostly single women in car sales. I was surprised, however, to find that seventeen of the women informants were married. Nineteen of the informants had children school-aged or younger, and ten of these women were divorced or widowed heads of families, and only thirteen women out of forty-nine were single (never married) with no children. In spite of making work their first priority, among most married women, there was an ongoing conflict with family needs that made them exceptionally interesting as subjects. They talked about wanting time to sew their own clothes, make family dinners, and spend time with their children or grandchildren. When they could not do this, some married women agents got limited help from their husbands. But, Vita was the only one of the women I interviewed whose husband worked shorter work hours than she and was able to do a major share of the cooking, child care, and housework:

> My husband is at home more than I am and he cooks for us. It seems like the answer is to have a really helpful husband. If he hadn't been so supportive, I could never have done it, because the hours I work are so long. My husband gets home right after my son gets home from school, so he is there with him.

Most other women with young children did not have a willing husband available to them with a work schedule compatible with their children's needs. Such women made do with a combinations of day care centers, after school care, and the help of neighbors and friends. Oprah had such an arrangement: "All the kids go to the neighbor's house after school. My husband comes home at 6:00 at night and picks up the kids, so it is all right."

Hiring a live-in person was another solution for dual-career marriages. The housekeeper functioned as a "wife" who allowed both the man and woman to pursue jobs with long hours. When her youngest child was born, Rita hired live-in help until the baby reached school age. She disliked this arrangement, however, and said, "It is very costly and gives my husband and me little privacy. The kids aren't happy and my husband and I fight a lot. When the baby's old enough to be left with the neighbors after school, I will dismiss the nanny." Arlene's sons, by contrast, were eleven and thirteen and did not need a nanny. She said, "My sons fend for themselves on 'bust out days.' They don't need a baby sitter, but meals are difficult. Even though my husband works somewhat shorter hours, he seldom helps out with family chores like shopping or cooking."

Some divorced women looked to ex-husbands for help in child care, in a compromise similar to that which married women used. Though Leah was divorced, she considered herself fortunate because she could depend on the children's father for help with the children. She said, "My ex and I have a great relationship. He gets the kids on Wednesday and they stay with him Thursday, Friday, and Saturday. I only need a sitter on Tuesdays. That's a plus."

Other single parents got help from family members. Oprah depended on her mother when she started out. She said, "My son was very young when I started in the car business. My mother would take care of him. She lived very close and I would just drop him off at her house."

Two other divorced women, with young children, said they were forced to live apart from their children because they chose to make their living in car sales. Both women had given custody of their children to their ex-husbands. Karen's children, for example, lived with their father's mother:

> I gave custody of my children to my ex-husband and his mother looks after them. I needed a career and I could not get one and raise my children as a proper mother. I'm not really happy with this situation either. My life now revolves around my work. Although I would like to do something else eventually, because I feel guilty because the children are with their grandmother. I know they're okay, but I miss them.

Jean's children were five and seven years old and lived with their father in a nearby state. She visited on Sundays. She complained, "I could not spend enough time with them, so they chose to live with their father. I feel bad and guilty, but I'm becoming successful, and maybe one day they'll be able to come

back." Even with help, most divorced or widowed informants with school-aged or younger children said they could not spend as much time with their children as necessary. Carol also felt guilty:

> I have three kids. One's fifteen, one's thirteen, and one's ten. I try to spend whatever time I have with the kids because the little guy is still being molded. On Sunday I help him with his homework. Sometimes we go to a ballgame. My weekday off usually turns into a fiasco, because you're running around to like either the eye doctor, or the grocery, and you're trying to get this done and taking your kid to the dentist, and you run, run, run. And, I still think it's not enough.

Francis, a single parent with three small children, said single women with children should not be in this work:

> This isn't the field for single women with small children. In fact, most women with kids should not work these hours. If you're working nine to nine you could see them in the morning. If you live close enough you can run home for lunch. What do you do then? You get sitters and wake them up at night and say "Honey, I'm home!" You miss too much.

Many mothers, both single and married, said that when things were slow at work, it was doubly hard for women agents because they thought about their children and the work waiting for them at home and how they wished they were home. Barbara had latch-key children:

> This job requires being a nine to nine four days a week. It is very hard to do good parenting. A woman is a mother. You can't be gone that many hours and do a good job of parenting. I work a lot of hours, so my kids are alone a lot. Once they come from school that's it. They can't leave the house. They wait till I come home. They have to stay in because I can't control what goes on out there, so that is a hard part of this job. I think I am probably a bad mother.

Eight of the nine married men in my study had wives who stayed at home with their children. Although the men expressed concern over the long hours in regard to family, they were satisfied that their wives were giving the children adequate care and were proud that they could make enough money so their wives did not have to do full-time work. Car sales agents, like other men who have been able to "obtain challenging work [did] not wish to reduce commitment to that work" and did not feel guilty about their decisions (Weiss 1990:265). Rod, a married man with three little children said he missed seeing

his kids because they were usually in bed when he got home, but his wife and the money made it all okay:

> Well, I have two days off a week, Wednesday and Sunday. I live an hour and a half away from here. I leave early in the morning. I usually get home late because there's usually something going on late at night here and I don't get out at 9. We close at 9 and I usually get out at 10, or 10:30. By the time I get home, the wife's in bed, the kids are in bed. I say "hello" to her in the morning and on my day off. But, I know the kids are well taken care of and the money's good. It's a choice I've made.

Women agents however, were reflective and more guilty about their choices. Their choice to put work above family needs resulted in critical observations about their social and family lives. Yet none of the respondents left the field because of these problems. High earners like Fran, Barbara, and Carol were aware of what the business did to their family life, but did not quit even if their decision was extremely stressful. Other high earners, like Jean and Karen felt their children were probably better off living with their fathers. Thus, women who remained in sales justified what they had to do through money, similar to men agents, even though they did not like many of their compromises. They said they were bad mothers or wives, but did not seem to care in the short term. They were waiting for the children to grow up or their next marriages to be better or for things to somehow change. They were, as they had been, "becoming successful."[5]

Notes

1. The emotional and social lives of men who do well at work (i.e., own their own homes, are solidly established in a line of work) and are middle class or better have been studied by Weiss. He argues that "work is a greedy institution taking as its due whatever time is given to it and wanting more. Prodded by their own ambitions and anxieties, by the pure attractiveness of their work, and by the many rewards and penalties of the workplace, men accede to work's demands. They give their families residual time, time not required by their work, or time when fatigue prevents them from going on with their work. They rely on their wives to help maintain emotional equilibrium, to care for the children, to provide the men with a home, and to help them maintain a social life. If men's wives have careers as demanding as the men's, there is the further problem that both the men and their wives will often be unavailable to respond to the partner's needs" (1990:261). There are, however, men who take alternative paths and make a decision to put more emphasis on family life than on work. Their career choices reflect this decision. See Kathleen Gerson, *No Man's Land: Men's Changing Commitments to Family and Work* (New York: Basic Books, 1993).

2. "Women face a set of dichotomous choices in which work and family commitments are posed as competing, alternative commitments" (Gerson 1985:193). For literature on problems women face when they try to combine work and family life, see Kathleen Gerson, *Hard Choices: How Women Decide About Work, Career, and Motherhood* (Berkeley, Calif.: University of California Press, 1985); Naomi Gerstel and Harriet Engel Gross, *Families and Work* (Philadelphia: Temple University Press, 1987); and Arlie Russell Hochschild *The Time Bind: When Work Becomes Home and Home Becomes Work* (New York: Metropolitan Books, 1997); Faye J. Crosby, *Juggling: The Unexpected Advantages of Balancing Career and Home for Women and Their Families* (New York: Free Press, 1991).

3. This is similar to janitors who drop into neighborhood taverns to "find some relaxation and to tell each other their troubles" (Gold 1964:32).

4. See Patricia Lunneborg, *Women Changing Work* (New York: Bergin and Garvey Publishers, 1990).

5. Kelly argues, "Establishing a successful career ... requires integrating one's private and public lives. The task is much more than an individual or even an organizational matter. It involves a re-conceptualization of sex-role ideology; the acceptance of this new ideology by both men and women and the adoption of this way of thinking by the nation's political, economic, and judicial institutions." (1997:158).

7

HAVING WHAT IT TAKES:

WHO LEAVES, WHO STAYS,

AND THE POTENTIAL

FOR BUILDING SUCCESSFUL CAREERS

> Salesmen need to get hyped up so they drink. It's kind of scary. I see so many men who do that. Some drink during work, but basically it is after work. My son sold cars too. He made a lot of money but he was not happy with the pressure to sell and the lies he told. He got wrapped up in drinking. For the last years he was doing drugs as well as drinking. He finally quit.
>
> —Mike, *45-year-old ex-general manager.*

> I see an upgrade of people in the automobile business. Everyone has their image of the used car salesman with the cigar and bright jacket and so on. These old time salesmen never had a home life. They often drank. They gambled. They were working nine-to-nine, seven days a week. The people coming into the business today don't have to work these hours anymore. It is not a low-class type of job anymore. I think we're getting into this field a more educated person. You see the young men and women that are coming into the business, a good portion of them have gone to college. They want a professional job and to some extent I can see where this is going in that direction.
>
> —Joyce, *25-year-old with three years of business college*

All sales agents tell stories about what their work world is like. Agents agree that they must work under unstable market conditions, they have no professional organization, no union, and little support from co-workers or supervisors. Those who leave or are fired highlight the conflicts they face to explain their desire or

decision to leave or why they were fired. Those who stay try to smooth these conflicts over to cope with them. Most sales agents move from dealership to dealership in an effort to find a stable agency, a popular selling car, or eventually, a management position.

Leavers

Lack of Stability and Respect

A large percentage of the sales agents I interviewed were not successful at car sales. Many got fired, they started over at a new dealership, and got fired again. Others left of their own accord. They went to new dealerships looking for better conditions and if they did not find them, eventually they dropped out. For these reasons, car sales is called a "revolving door" occupation. Frank says his fifteen years of experience in the business bear witness to the fact that it is very difficult for either men or women to survive in this environment:

> In the auto industry, 94 percent of the people don't make it six months. They burn out. It is typical. I've seen it here. To learn the ropes, to hang on, to make it through that first year is unbelievable. The first six months 94 percent go and then there is an additional 2 to 4 percent that drop out and don't make it a year.

The revolving door aspect of car sales is a major reason sales agents quit. They get tired of starting over. Marvin talked about the difficulty of staying at one dealership:

> Because there is very little security for dealers, they try to get the same job done for less money or they think if they hire somebody else the business is going to get better. They fire salespersons in slow times, change managers, cut commissions and blame us for not selling. This gives salespersons so little security or respect within the industry it is a nightmare.

The resultant forced move from store to store by a car sales agent is called "jumping." According to Larry, a sales manager, it is quite common:

> The car business is notorious for what we call "jumping" from dealership to dealership. Salesmen all go from store to store. You can't stay too long at one store because things happen. Since I have worked here I couldn't tell you the people that

have come and gone, the "Floaters." I couldn't count them.
We had a list at one time.

A Philadelphia-based out placement firm, Right Associates, says 85 per-
cent of car sales agents who came to them for counseling held positions that
were eliminated in a merger, acquisition, or downsizing.[1] Both men and women
are concerned with the instability of the field. But many women seem to try
harder to stay with one dealer. They say they dislike change. It disrupts family
life and the possibility to get repeat customers and referrals. Perhaps resisting
change is part of their upbringing. Women have always been encouraged to be
stable and take care of the home while men have been encouraged to go out into
the workforce and the larger world. However, if women find they are not treated
well at their dealership, similar to men, they move. Chris was dissatisfied with
being forced into horizontal mobility:

> There was a change in sales manager. I was originally paid a
> percentage agreed upon up front and I exceeded what they
> penciled me in for or anticipated paying. Even though I made
> them larger dollars, they wanted me to change the percentage,
> decreasing it. I did my job and then I did better at it than when
> I originally started and now they want me to work for less
> money. I want to stay on, but they are making my life miser-
> able.

Other sales agents in my study were dissatisfied with their jobs. They
blamed management's expectations about how sales agents should treat custom-
ers, for the disrespect they got from customers. They felt they could do a better
job of selling if management did not stress profit motives and high pressure tac-
tics over customer needs. But in the world of high-commission sales, each cus-
tomer is a means to the sales agent's future success. Concern with the needs of
others must take a back seat to putting people to use.[2]

Service Versus Profit Goals

Many women agents found it hard to disconnect themselves and their work from
ethics. Andrea talked about how difficult it was her for to feel good about her-
self and make a high profit:

> In this business a measure of how talented you are is how
> much you can sell a car for. Salespeople have to talk custom-
> ers into buying add-ons and paying high interest rates. They
> brag about it to each other. If you don't do well and you don't
> make any money, you don't have a job anymore. It's real hard

to be where you're making the customers happy and you're
still making enough to make yourself happy too.

Some men agents also had difficulty making a high profit from customers.
Usually they got fired. Scott was in the business less than a year and went from
dealership to dealership, staying less than six months at each location. He was at
his current dealership only a few months when I interviewed him. He had been
fired from his previous dealership after a similar amount of time and blamed his
dismissal on his inability to use high pressure tactics:

> I talked to the customers and I tried hard, but I couldn't make
> the kind of profit the management wanted and still close the
> deal. The dealership was one where you must learn to close
> your own sales for the amount the management wants. The
> bottom line was I didn't do much for them [customers] or
> management, because these same customers could have talked
> to the manager and bought from him.

Edith had worked in car sales for ten months at the time of our interview. I
called her a few months after our interview and she told me she was considering
leaving the field. She said car sales involved too much pressure and not enough
service:

> I need a break from car sales until it really changes. I feel I
> would be more effective in a position rendering the same kind
> of service through servicing people's needs more, not shoving
> people into anything that they're not ready for.

Leah quit after trying valiantly for eighteen months. She said she could not
convince herself that it was right to ask customers to pay high prices and found
it difficult to talk them into buying cars they did not want or could barely afford.
She felt dishonest pretending to be on the customer's side when she was really
on the side of management. She disliked being the object of customer's distrust
and she was tired of their rejection. Leah could not justify the ideology that this
practice made happier customers or that they received better service. She could
not convince herself that selling a car for the highest possible price was some-
thing of which she could be proud:

> I am leaving the car business. I don't like the car business–the
> selling aspect of cars. I don't like that feeling. If you do well
> and you make your boss happy, you feel sick inside. If you
> don't do well and you don't make your boss happy, you feel
> sick inside.
> 　　I'm getting out of cars because I have a conscience. I am
> not the kind of individual that can gain your confidence and

respect during the initial transaction of purchasing a car and then when it comes down to the dollars and cents treat you like I never met you, which is to make the highest possible profit off of you. Ninety percent of the people in this business have no conscience. When you purchase a car and come back they'll start hiding. They pretend they don't know you for fear you're coming back to make a complaint, to address something that was not dealt with properly in the beginning.

I am tired of selling cars–tired of approaching people and having that look on their faces and having to overcome that objection of, "No, I'm not a crook" and "Yes, I'll sell you a car cheap." And then if you sell too many cars cheap, you got the boss saying, "What are you doing, giving my cars away? Do you want to work here long?"

Because Leah was hired as a token black at an all white dealership in a neighborhood that was beginning to change racially, she was probably given more freedom than other salespeople and allowed to try out her ideas. But eventually she got tired of being harassed and unappreciated. Joe was also unhappy with the work and talked about leaving. He said agents who did well had to be "fast-talking bull-shitters" and "many get sick of their own reputations."

Managers did not take sales agent's feelings into account. They also did not value sales agent's methods of sales if they were different from the prescribed models even if these methods sold cars. They blamed the workers, not the organization or the structure of the business. They said that newcomers who got fired just "don't fit the mold," or "aren't aggressive enough."[3] Pete explained firings of people who did not make sales fast or profitable enough as rational for both the salesperson and the dealership:

They let one guy go because he was taking a lot of people, but he was having a real difficult time closing at our price. He couldn't build value into the car [sell extras]. I worked him and trained him and spent a lot of time with him and still he couldn't get their [customers] money. It was probably better for him though, because there was no way he could have survived on what he was making, and the dealership was hurting too.

Stayers

Other sales agents in my study managed to stay in the field for an extended period of time and make a better than living wage. Because there is no mandatory schooling or necessary qualifications related to car sales, anyone can get hired

and call themselves a car sales agent. But the ability to gain some measure of stability (remain in the field at one dealership for at least two years or more) is considered a means to success and looked upon highly by workers. Even agents who were quick to move into "greener fields" when things were slow at their dealerships said they were more apt to be successful when they could be stable.

Stability

Vita said "Floaters," those who went from place to place or in and out of the field looking for "fast money," did not become successful:

> People who want to succeed have to be stable. They have to be dedicated and work at it every day, day in and day out. No matter if you've been in this business five years or two, the popularity of cars and dealerships are constantly changing. It's hard to find a stable dealership and stay there. So if there's anybody that would come up and say, "Should I go into sales?" I'd tell them "yes, if you want to stick to it and be that dedicated to it and keep trying, or else you'll be just like all of the other goof-offs coming in and out this door looking for greener fields and fast bucks."

Nina agreed that the fields were usually not greener at other dealerships:

> I have been here five years. I do not want to lose old customers and do not believe the grass would be greener anywhere else. I have been offered jobs at other dealerships where they told me I had greater possibilities for making more money, but I turned the offers down because I did not believe it [the money] would be there once I changed. I saw other people fall victim to these management ploys and I'm leery of false promises. Even when this dealership changed owners I stayed.

Patsy who had been at her dealership for twelve years agreed that lateral movement usually meant starting over, not moving up:

> Anytime salespersons change dealerships they have to prove themselves all over again. This means talking walk-ins, losing referrals and repeaters, and working out relationships with management. Then you don't know if the cars are really selling like management says they are. There is no utopia, so why move? I sold on the floor here for nine years. I have been sales manager for the past three years. If there is something I

am unhappy about here, most likely there is something I will
be unhappy about somewhere else. The dealership is fair, the
people are fair. Why start over? As long as the benefits of
staying outweigh the liabilities of changing, I will continue to
stay here.

Aside from being a stable worker, Oprah said she was a success because she
knew how to choose a good stable dealership. She defined this as a dealership
with an active owner who was personally interested in the employees:

I have been with the same dealership for fifteen years. I've
never had a change in ownership. We have a strong dealer-
ship. The owner comes in. He is a very good man. He knows
all his employees by name, first, last, and speaks to everyone.
He owns seven stores and he can tell you everyone that works
for him. He asks, "How are you doing?" He knows if your
children have been sick.

Men sales agents also said it is good to work at a well-known, stable deal-
ership that has been in business for some time. Usually these are family-owned
like the one where George has been working for eight years:

I feel working at Greens is the finest place to be. I feel you
must be very honorable to your profession if you want to suc-
ceed and not work at "fly by night" dealerships.

According to Rod, dealerships who hire floaters are not good places to work:

Smiths is a top-of-the-line store. They don't get any better.
The salesmen in this store have been in the business five to
twenty years. They are all very mature, very successful, and
very professional. Here we are given a very personalized
structure. We are our own boss. The other place I worked
there was a much younger staff. They didn't want people with
automobile experience. The owners kept changing. It was not
a very professional place.

Another way to be successful according to sales agents is to work in a store
located in a higher-class neighborhood. Working in an area where there are pro-
fessional people is envisioned as an indicator that the sales agent can expect
more respect and easier sales from customers:

Working in Homer Park [elite suburb] I should think you
would know that we are very successful here. This is a profes-
sional type community and customers treat salespersons bet-

ter. This isn't West Avenue [inner city lower-class neighbor-
hood]. Our customers can afford the merchandise and they
come for the special service we give them. We serve bagels,
cream cheese, lox, and coffee when customers bring their car
[Lexus] in for service.

Sales workers "bury the low status of the work they do in the name of their
firm" (Mills 1951:243).[4] However, if dealerships are more stable, it makes
sense that sales agents would feel more secure at their work and be less pres-
sured by management. Furthermore, Evelyn found that working at the same
dealership for a lengthy period of time helped her to get a base of repeat and
referral customers:

One of the reasons I do so well is because I stayed in one
place. I have been here four years. Because of that I have peo-
ple come back to me. I get a lot of business from referrals.

After nine years at the same dealer, Ann rarely needed to take walk-ins:

If you want to make a lot of money in this business, you build
a clientele by staying in one place. You keep business because
people feel comfortable coming back and working with the
same person.

At first, I found it hard to believe that sales agents could make a living
from repeat customers who might come back every two to four years to buy
another car. I became convinced, however, when I had the opportunity to watch
Ann prospect for repeater sales after an interview. She had a list of people who
bought new cars from her on a regular basis. She contacted the people on the list
when the time for reorder grew near and told them about cars she had in stock
she thought they might like.

The first customer she called was a man who traded his car in approxi-
mately every six months. On the phone she talked to him about his loneliness,
the health of his dog, and some personal financial matters relating to the pur-
chase. Ann was extremely nurturing and the tenor of the conversation was that
of two longtime friends. She told me she had "inherited" this customer a few
years back when his regular salesperson left the dealership.

The second phone call was to the Mother Superior of a local convent who
regularly purchased cars from the agency for use by the nuns. Like the first call,
the talk was friendly and personal. Ann inquired about the health of other nuns
whom she knew by name and heard about events of the past year.

Self-Esteem/Professionalism

Sales agents like Ann, who stay in the business and become successful, begin to think of themselves as "professionals." This helps them feel good about themselves and gives them the self-esteem that the public does not equate with this occupation.[5] Car sales is on the borderline of negative evaluation. It is a very low-status occupations whose members are in a precarious position regarding job security and stability. It has no organization to support its members. There is no standardized period of training and no body of esoteric knowledge. Car sales agents service customers rather than clients, have no written ethical codes and are motivated to pursue monetary reward as an end in itself. These factors are among the reasons why sales agents continue to appear untrustworthy. Self-esteem for people working under these conditions is difficult. Car sales agents adapt "co-opted" professionalism, through which they define certain characteristics as professional even though these characteristics deviate from the standard views of professionals.[6]

Proper Appearance

One characteristic management believed to be essential to becoming a professional car sales agent was having the proper appearance. Vic, a sales manager, believed dressing in expensive clothes and displaying social mannerisms borrowed from Hollywood and television celebrities of our times increased success. Vic pointed out that people cannot be a success if they do not look the part:

> Appearance is everything. You've got to look successful. Our salesmen are all required to wear coats and ties, which is the way it should be. It looks a little more professional if women wear heels. If they wear flats, it takes away from the dress.

Concern over clothes is probably a behavior left over from the days when clothes more readily depicted the type of work one did and thus the status they held.[7] Still, much free time and money are spent by car sales agents such as Cathy on buying clothes to help them be professional:

> I like to shop for clothes. You need it to be professional and if you can't afford it now, you'll probably make the money on your next deal. If I buy a $200 dress, I can say, "Well, that's alright. I'll sell another car."

Some sales managers also said professionals should present a high class demeanor. Rod, a younger sales manager said professionals had to look and act

as if they made money, to "dress for success," and to carry themselves "properly":

> You can tell a professional by the way he dresses. By the way
> he walks up to people and shakes hands and so on. Not the
> "schlocky" walk up to a person with a cigarette hanging out of
> your mouth. We've got more educated people coming into the
> business now. They know how to act.

Rod also gave an example of an unprofessional woman sales agent who not only did not adopt upper-class clothes and manners, but also had loose morals. This, too, is a common theme among both men and women informants.[8]

Proper Sexual Morals

Rod's assessment of his temporary colleague associated her lack of professionalism with questionable morals:

> She was new and she didn't know how to dress. She'd come
> in with high-heeled sandals, skin-tight pants and peasant
> blouses. Her hair was all ratted. It was like she was on a dif-
> ferent planet. She wanted to party all the time. She'd go
> wheeling out of here at night with her five children at home
> and she had her car stereo blasting. She'd say, "I'm going out
> partying. Want to go partying?" I'd go, "No!" She certainly
> wasn't professional. She didn't last very long.

Jean avoided male co-workers, equating sexual morality with professionalism and success:

> I consider myself a professional. I made a point of being
> straight as an arrow. Five or ten years ago it was unusual to
> see women in the business that were not tramps. They slept
> with the customers–customers and workers to sell cars. Not
> me.

Regardless of what characteristics they said determined success, all informants who defined themselves as professional eventually discussed success in terms of monetary goals.

Profit Goals

Most sales agents automatically considered themselves professional business people because the organization of car sales was profit motivated. Bill, a newcomer stated, "This work is automatically professional because it is business oriented. Here we are concerned with profit above all." Bev, also a newcomer to car sales, agreed that making money was the professional thing to do, "I try and do everything very professionally. I always remember in the back of my mind that it is a financial institution and I am here to make money."

Concern with monetary profit no matter how fairly gained or how much time is spent with the customer is still in direct conflict with the traditional definition of a professional: a person primarily concerned with service beyond a profit motive. Yet, Doreen, a high-earner, said making a profit was just, fair, and what business was all about:

> You know this industry has such a bad reputation and I get quite offended by someone who tells me I should sell him a car for $2,000 less than we probably paid for it because it is an '89 [new models just out are '90s] and that offends me. We have a right to make a profit just like Jewel does. The owner puts the money out to buy these cars and we are going to make a profit on these cars. That's what he pays us to do. I try not to rape anybody, you know, to make so much money that it's unreasonable, but I think it's fair to make X number of dollars over what you paid for the car. If you look at percentages on what mark-up there is on washing machines and dryers, or refrigerators or clothes and food. ... Cars are nowhere near that, even if you stayed at full list.

Nora used a similar definition for professional. She made sure her dealership did not lose money by being sued by dissatisfied customers. Listening to people's complaints and soothing them could save the dealership money. This was truly professional work:

> A professional will bend over backwards to make sure their department is run without any snags, without any legal problems. A lot of dealerships have a lot of legal problems, a lot of complaints from the Better Business Bureau, a lot of complaints from the state attorney's office. I solve those problems before it even gets that far. We've got a real good reputation. I know my job. I know what is required. I carry it out to the best of my ability. I take care of customers. If a customer comes in with a problem with contract payments, I listen to them. I try

and help them. I take care of people. I make money off of
them, but I earn what I make.

Thus many informants separated themselves from the negative status of the
business. They said they were professionals. They attributed their professional
success to their ability to stay at one dealership for any length of time, their un-
derstanding of how to choose a good stable dealership at which to work, their
knowledge of how to dress in proper high-class attire, and their discretion in the
use of morally correct sexual behavior. Most of all, they attributed their success
to their professional profit-oriented attitudes. Men and women blamed sales
agents who preceded them for giving the occupation a bad name. Most women
claimed to be different from the shoddy car sales agent of the past. And they
were, but to what extent?

To return to the quotes at the beginning of this chapter, neither Joyce nor
Mike have captured a totally accurate picture of car sales. Certainly not all car
sales agents drink or take drugs. But, Sundays aside, they still work very long
hours. Not all men or women agents are garishly dressed. The men and women
that I observed were dressed in all manner of ways. Some wore very casual
clothes. Some smoked cigars and wore bright colored jackets and pants. One
woman was dressed all in bright purple, including her glasses and finger nails.
As previously discussed many sales agents still drink and most have limited
time for social and family life. On the other hand, although I found only one
sales agent with a college education, some new women agents do have more
education and as I have previously pointed out, are less aggressive. Perhaps the
field will become more professional in the distant future. But Joyce's belief that
the field is rapidly becoming more professional (as the word is defined at the
beginning of this chapter) is based on wishful thinking, thin reality, and a new
definition of professionalism, relevant specifically to the world of car sales. That
some women are building successful careers in this world, is however very real.
The following section describes the types of mobility choices available to car
sales agents.

Career Lines

Higher Profit Stores

If the dealership that a sales agent has been working at is small and times are
hard, some women move to a store with a higher volume of sales or a more ex-
pensive product that would bring in more commission. Sally reported:

When I started, it was at a little store. They sold about fifty
cars a month. It was nice, because they didn't have a whole
lot [of cars] and I got to take my time doing what I had to do.

> But I didn't make very much, and as time went on I got a little better and I went into a little bigger store [same manufacturer] and obviously the bigger the store the more people, the more sales, the more money you make.

Fran, moved to an agency that sold a more expensive product and probably made more than any other sales agent in the industry one year:

> I was selling Chevys. The timing was right and the product was right, so I moved. I made $85,000 selling "Chevys." The next year I moved to Cadillac and made $160,000. Those numbers were a joke. It's difficult now. I'm not making nearly as much as I made then, but I'm still doing fine.

But not all agents want to move around and still continue to be sales agents. Many want to be in management. In other fields, if sales workers move on to become managers they are considered to have moved out of the sales occupation and entered management. In car sales, this is not so, because of the limited formal upward mobility pattern. Car sales agents who become managers can be compared to women managers in other fields who move into lower management positions.[9]

Management

Management positions in car sales are positions such as rental or leasing managers, managers of used car departments, or assistants to the finance manager. These positions are quasi-administrative and do not carry much authority or pay. Such movement means longer hours, a lot of extra paperwork, and word processor and clerical duties like those required of secretaries. In addition, the pay is so low that women must continue to sell cars to make a living. However, these positions give sales agents a chance to learn more about the business and eventually work themselves into full-time higher-management positions such as general manager.

Finance Manager

One management position most coveted by women is the position of finance manager. Finance managers arrange financing for the customer after the purchase has been decided. In addition, they sell add-ons such as warranties and rust proofing. Women moved into this position through a number of paths. Carolyn was hired as a finance manager from outside the agency because she had a business school background even though she never sold cars. Evelyn

proved she could sell cars and was then sent to a two-week course in finance management by the dealership. Oprah applied for a job as a sales agent and was asked if she would consider assisting in finance instead. Most women like Jean, Norine, Barbara, and Nora, however, worked their way into finance by starting as sales agents and initiating an apprenticeship with the finance manager on a part-time basis, doing much of the clerical work plus selling on the floor. Barbara described this process:

> I did sales for about six months and I did really well at it and I saw I could sell after-market stuff. You know, things that go on the car after the sale, as in rust proofing. I did really well at that and that's what you need to learn how to sell if you're going to be in the financial office. Now I'm an assistant, kind of like an apprentice to our finance manager. He's training me. I started by doing paper work. I get a salary plus I can sell if I want on Saturdays.

Sometimes women were lucky. When Nora's boss quit, she got his job:

> I initiated it on my own. They had a mini-computer. It was an old-style one and I would go in there and ask the current financial manager, "How does that work and how do you figure out what you have to do?" I didn't know anything about the job. He showed me all the books and how to work the machines. When customers gave him finance contracts, I said, "Let me try and do this for you." And I would do it two or three times a week. When he quit the agency I was already familiar with how to do it and instead of putting an ad in the paper for a new finance manager, they just let me do it.

Marsha saw finance as a realistic goal for women because managers and owners were advertising for women to fill this position. She thought this was because of gender expectations for women. She explained, "Managers think, 'Whatever the public wants. Whatever works.' The public sees finance as more of a clerical position, so that's acceptable for women." Carolyn agreed that women in finance were readily accepted by the public who saw them as order-takers or clerks, roles in which they expected to see women:

> Women in finance are much less intimidating to a customer. Women in a finance office can sell more because the customer doesn't feel like they are being sold. If the salesman gave them a real bad time out there on the floor and they feel he was trying to get them to pay too much, if they came in here and saw a man, they would feel that same defense. When they look at me I'm not going to have them do anything but sign

the odometer statements, sign the documents for the state, and make sure all the paperwork is right. That's harmless enough. When they are in this office I always say, "call me Carolyn the clerk, but buy extras from me."

Traditional gender expectations affect the duties and treatment of finance managers by owners as well as customers. Nora argued that women in finance did their own paperwork whereas men usually had secretaries to assist them. For this reason, women saved money for dealers, but were overworked and frustrated:

> When you're initially trained the paperwork will bog you down. You could become extremely frustrated when what you're really here for, to generate a profit, is going to suffer because you're so bogged down with paperwork. Men don't have the patience, so they want help. But once you get all that down, you can do okay and it seems that more and more they specifically want a woman for this job.

Jean said that women like finance, even though it is equated with long hours and work overload, because it is more prestigious, pays more than straight sales, and finance managers do not have to deal with the pressure involved in the initial sale of the car:

> When you sell cars on the floor, you get paid a commission on every car you sell. When you work in the finance office you're being paid a commission on every car that goes out based on the profit that you are actually generating in dollars. Every customer has to go through financing. Even if they aren't financed through you, they still have to be billed out. So you have an opportunity to sell different things to people— warrantees, insurance. You can double your money in the finance department, and there's less pressure selling.

Jean said people could make a large income in finance:

> In this office, percentages are worked out depending on the number of retail units they sell in your store. You're going to make something close to $60,000 plus, even in a small store. Here I will probably make $75,000 to $90,000.

There is a gradual movement of women into areas of car sales management other than finance. These positions, sales manager and general manager, are somewhat different from finance manager.

Sales Manager

According to Dorene, the major concern of the manager must be with the pro-
ductivity of others rather than oneself, and supervising men is difficult for
women:[10]

> I have been a sales manager before, but not in car sales—in a
> woman's clothing store. It is tough managing men. You have
> to push them, get them involved. They don't take women seri-
> ously and you don't get a lot of help from higher-ups.

Despite the difficulties and although their numbers are few, women are becom-
ing sales managers of automobile dealerships. Dorene and Patsy were two ex-
amples. Both women moved up the career ladder from sales agent to sales man-
ager. Neither actively sought the position of sales manager, but were recruited
by their bosses. Dorene said:

> I did not look for this job. I was actually surprised when Rod
> [the general manager] suggested this. He told me at that point,
> not, "Let's see how you do." But, "I've always wanted a
> woman in that position. I just had not found a woman strong
> enough to do it before." And, I appreciate the opportunity to
> be able to do it. I can handle the responsibility. Rod has been
> nice enough to offer me an opportunity to be able to grow and
> there aren't many women sales managers and to me that is
> more important than money at this time. If I stay with Rod and
> prove myself to him, the money will come. Eventually it will
> be there, but I have to pay my dues. I know I could walk down
> to Ford. I have been offered on several occasions a job in
> their finance department, but I also know I would never be a
> sales manager there. I want that and I am willing to sacrifice
> some money.

The situations of these women are somewhat different from that of men.
Dorene was so grateful for the opportunity to train for the job, she agreed to do
the work without a pay raise, and Patsy's said her work was divided with a part-
ner who happened to be a man. "I am a full-time manager now, but Larry and I
work as partners." Dorene and Patsy moved up the ladder in car sales, through
stability and apprenticeship, going from the sales floor to management. How-
ever, an important similarity in their situations is that both women have de-
creased family responsibilities. Dorene is divorced and has no children. Patsy is
married, but her daughter is grown. An additional gender-related similarity in
the promotion to sales management for Dorene and Patsy is that they are paid
less than men doing similar work.[11] Dorene and Patsy had titles as managers, but

their jobs were divided and had limited power. I observed Patsy consulting with Vic, the general manager, before making decisions and on many occasions I heard him lecturing or correcting her. Patsy shared her managerial duties with a man, allegedly on an equal basis. However, she said, "He is located in a back office, less accessible to customer complaints and deals more with employee problems such as hiring, firing, and setting policy. I take care of upset customers, and locate cars for salespersons."

Because women have only recently been allowed and encouraged to enter car sales on any level, their numbers are especially low in upper levels of management.

General Manager

When I began this study, I could find no women at the highest level of car sales management, general manager. Karen, however, wanted to become a general manager and saw this as her next career step:

> From here I am going to become a general manager. That's what I want. I didn't ever think that was something I would want or could do, but it is where I am now. The next move to make would be general manager. I see that happening relatively soon. I have been in the business eight years. I am ready to make a move.

Carolyn was not ready to make her move, but said she would be in the future, "General manager? Sure! I'm learning all I can. I am certainly not ready to be a general manager yet, but after a couple years of this and other experiences, then I will be there."

The upward path from general manager leads to partnership with an established owner, buying out an existing dealer, or opening a new dealership.

Ownership

Most women sales agents were afraid of the risk of owning a dealership.[12] Sally said she feared bankruptcy:

> Buying a lot is not easy. You have to put a lot on the line— your personal guarantee on everything. If for any reason you fail, there goes your house, there goes your savings, there goes your stock, there goes everything you've ever had...I've seen a lot of bust outs by good people.

Rita was also afraid of the risk. She said, "My husband says, 'Gosh, you know with what we know, we could do well. Why do we always do these things for other people? Look at all the money we're making for them.' But I don't know ... I'm not that brave."

Active women owners are still very scarce in the automobile business. In order to locate a woman who was willing to give me an interview and who was not an owner in name only, I was obliged to go outside the Chicago area. Helen, a widow who took control under extreme conditions with no previously mapped-out career plans, was a great success:

> I took over my husband's business when he first passed away. The choice was either I sell it or I take it over and run it. Had I sold the business at that time, what I would have received for it would have been a very small amount and I was not going to let all the sacrifices that my husband made and that I made, really, as being part of him and his wife go for nothing. So I thought, "I really don't have anything to lose. If I keep it a year and I don't do well, I will sell it at the same price that I'm selling it now." So I made my decision to go ahead.

Helen helped out in the office of her husband's dealership, but was mainly a homemaker. She said it was rough going at first, and there were times she was afraid she was not going to make it. She had to convince the manufacturer that she could learn the business and make a profit. She had to associate with other dealers who were not very receptive to having a woman around. She had difficulty keeping male employees who did not want to work for a woman and there was family to contend with because her children were still young. Her story clearly reveals the complex difficulties women face in men-dominated careers:

> I was the first woman automobile dealer in my city. I was afraid they were not going to let me keep the dealership. I went to dealers' training courses. I went to every single dealer meeting. And believe me if you don't think that's hard when you're the only woman ... I learned quickly to listen and not say anything at meetings. There are a lot of chauvinists in business. Men are incredibly patronizing. I just overlooked it. The top was that some thought I could not do it and a man could have done it, you know. The hours were a problem. At the time I started my youngest son was twelve and my daughter was sixteen. When you're a woman you do have both worlds you have to worry about. You cannot forget one you know, to sacrifice one for the other. You still are a mother. You still are a business woman. You just have to combine both. When I first took over most of the workers walked out on me. So I thought I should be loyal to everyone who stayed.

I had to learn how to fire people. If people do not sell and you still think you should be loyal to them, you have to think about the fact that they are not being loyal to you and they are not being loyal to their co-workers. I had to change managers and I had to change sales-persons. This is new to me and it is new to most women. We have to change. We don't know how to fight the way men do either. They are able to sit down and discuss business concerns and smile at each other and then they go out there stab each other in the back and think nothing of it. You are not going to be a dealer just by selling cars for a few months, or a year or two. There are so many aspects of the business that affect the dealership besides the sale of cars. You have a service department to content with, parts department. You've got used cars, body shop, and everything has to click. Four years later, Helen was considering the possibility of opening another dealership. Before I had two goals, trying to keep the business going and my children going. Now that the business seems to be going and my children are older I'm still scared, but I'd love to buy another dealership. They're very difficult to get in this area. People are not going to sell. It's very difficult to buy a dealership. I'm trying to find some-body who's willing to sell. Why? Because I am finding this experience so exciting. There are so many worlds out there to conquer. I wish I was ten or fifteen years younger. But, that's not gonna make me stop. I'm not gonna stop because of my age, you know. It is a wonderful feeling. I cannot even explain it. I am tired many times. I go home worn out and think, "I cannot do this another day. I cannot go another day with the pressure of this job." But the next morning I'm up at 5:30, 6:00 getting dressed, and I can hardly wait to come in. It's an exciting, interesting, challenging, demanding business. It's maddening sometimes, but it's exciting.

Helen did open another dealership and in 1999, Helen is still operating two agencies. She credits her success to becoming "tough" and she encourages her women workers to be likewise. Other women are also successful. Fran has been selling cars for twenty-two years now and is still making "good" money. Doreen is still a sales manager and Evelyn has become a finance manager. Laurie still works for her father-in-law and Nora is hanging in there after thirteen years and a shift in agencies. Other women have had mixed success. After sixteen years, Ann was fired. The owner said she had "lost the fire to sell." Ann believes she was fired because she was "fully vested in a pension plan by the original owner and the new owner felt it cost the dealership too much to keep her." Some women have left the field and gone into other occupations. Other women cannot

be located. They are either "jumping" or have also left the business. (See Epilogue for person-by-person longitudinal profiles.)

Notes

1. See Matt DeLorenzo (1988).
2. See Earl Shorris (1994).
3. "Agents who can stand up under the stresses and anxieties of the life insurance business and survive in the industry cannot be expected to see through the logic of the sales process to the contradictions on which it rests. Such a vision would destroy their effectiveness by shattering the illusions on which their careers depend," (Oakes 1990:97). There is significant literature on the logic of the sales process and its effect on sales agents. For example, see Jason Ditton, "Learning to Fiddle Customers: An Essay on the Organized Production of Part-Time Theft," *Sociology of Work and Occupations* (1977), 427-450; David Mayer and Herbert M. Greenberg. "What Makes a Good Salesman?" *Harvard Business Review* (July/August 1964) 119-125; Massami Oda, "Predicting Sales Performance of Car Salesmen by Personality Traits," *Japanese Journal of Psychology* 54 (1983) 73-80; Robert Prus, *Making Sales: Influence as Interpersonal Accomplishment* (Newbury Park, Calif.: Sage Publications, 1989); Robert Prus, *Pursuing Customers: An Ethnography of Marketing Activities* (Newbury Park, Calif.: Sage 1989); Robert McMurray. "The Mystique of Super Salesmanship," *Harvard Business Review* (March/April 1961) 113-122; and Dick Pothier, "Down With Niceness! Sell That Insurance," *Philadelphia Inquirer*, Oct.1, 1974 1 C.
4. Mills finds sales workers "bury the low status of the work they do in the name of their firm. These material signs of the status environment are in themselves crucial to the white-collar sense of importance" (1951:243-244).
5. Professionals are at the top of the prestige hierarchy of the work world. They are distinguished from mere occupations by the requirement of training in professional schools, a body of esoteric knowledge, memberships in professional associations, adherence to ethical codes of conduct, self-regulations, motivation to community service rather than self-interest and monetary rewards, and authority over clients. By making claims to these characteristics and standards, professionals gain status over other occupations. See Ritzer (1972) and Freidson (1986). Also see Robert Habenstein, "Critique of a 'Profession' as a Sociological Category," *Sociological Quarterly* 4 (1963) 291-300.
6. Car sales agents resemble alienated and defensive funeral directors studied by Habenstein (1963) and William Thompson, "Handling the Stigma of Handling the Dead, Morticians and Funeral Directors," *Deviant Behavior* 12.4 (1991):403-429, who promote themselves as professional counselors of grief, but whose negative public image grows from their desire to sell lucrative funeral plans in advance for financial gain.
7. According to Mills (1951), white-collar workers' claims to prestige, as the label implies, were originally based on their style of appearance. Although today, advanced technology has eradicated much of the need for blue-collar uniforms or protective clothing, working-class attire originally differentiated blue-collar from white-collar workers who could wear suits or fancier clothes, because they did not handle dirty or greasy objects.
8. Mills describes a similar success ideology tied to proper sexual morals. He talks about aspiring rural and small town boys who bolstered their egos and learned how to behave so they would not be intimidated by "City Slickers" who had better educations than they. The boys assumed "moral pre-eminence" and gentlemanly manners would

help them succeed. They subscribed to the ideology of the entrepreneur, the "man bent on success" who is "upright, exactly punctual and high-minded" who will "soberly refrain from liquor, tobacco, gambling and loose women [sic] and in all things will insure a moral presence of mind" (1951:261).

9. This is similar to the situation of women at the entry level in the corporate management structure who remain peripheral to the more established and powerful positions. See Kanter (1977); Harlan and Weiss (1980); and Hennig and Jardim (1977).

10. Most research on women in management concludes that men's attitudes are to blame for the rigidity in the traditional division of labor where sex bias excludes women from competing with men. Kantor (1977); Tausky (1984); Ellman (1973); S. Martin (1989); Cockburn (1991); Reardon (1995); Schwartz (1971); and Colwill (1993) describe the strong negative stereotypes of women as managers held by men managers. Women are said to put family above work, have high absenteeism, shy away from added responsibility, have less team spirit, and attempt to emasculate men. Danco (1981) describes similar feelings among male owners of small businesses. In the past, few women were counseled into business schools, and programs such as the Harvard Masters of Business Administration did not admit women until 1963 (Lopata, Miller, and Barnewolt 1986).

11. "Employers, well aware of past and present discrimination against women, offer women lower wages than men—not because they feel women's productivity is less than men's, but because they can use the social fact of discrimination to offer women less pay. Women accept lower wages because they need an income to survive and because they have not had the market power to enable them to bargain for more" (Berch 1982:66).

12. This may be because men who own even small businesses do not generally consider preparing their daughters to take over the business, concentrating only on sons and son-in-laws (Danco 1981). However, women are starting to take over businesses and as the culture changes, Lopata, Miller and Barnewolt believe "we can expect more men to trust women into inheritance of management, or as proteges or even partners" (1986: 188).

CONCLUSION:

THE SUM OF OPPORTUNITY FOR

WOMEN CAR SALES AGENTS

I began this research in order to capture a picture of what the world was like for women who accomplished careers in high commission car sales. This book has presented that picture in the women's own words. In this chapter I summarize their experiences as I see them. Also for readers who are impatient and usually read books by beginning at the end, this summary provides an introduction.

Most women car sales agents are new to the field and have not sold cars before. They came from service occupations in which men were the minority. They usually knew friends or family members (men) who sold cars or owned lots. Sometimes when women shopped for a car, they were approached by management and asked to try selling. Once they were hired, women got little or no training and had to learn how to sell while being harassed by men sales agents and men customers. They flew by the seat of their skirts, using relational techniques (i.e., "feminine" traits) that worked for them in other jobs or as housewives and mothers. Experienced women sales agents also learned to interact as "Tough Ladies," using a combination of "masculine" and "feminine" traits to close deals.

After less than one year, many women sales agents quit the field. Some got fired and others went from dealership to dealership in search of stability and money. Of those that managed to stay on, some became very successful. Some of these successful women remained in car sales at one dealership or another for fifteen, twenty, and even thirty years. Most women who stayed moved to quasi-management positions doing more than their share of work. A few went into upper-management, also doing more than their share of work. A very few became working owners of lots.

Women's secrets to success were to work at a stable dealership; to sell expensive cars; or to work for or have family in the business. It also helped if women gave up family and social life in the present and dreamed of a wonderful social and family life in some distant future. This could describe women's situations in most types of unskilled, semi-skilled, or blue-collar work dominated by men that pays a living wage. But, selling cars is different from other types of work. In car sales, women do not need to work as a team, as they do in police work, construction, or the military. They do not need lofty goals such as saving citizens or fighting for their country. Instead, they need to have a healthy

amount of distrust for co-workers and customers because they have to be able to pit themselves against customers who are armed with bluebooks and management and co-workers who want to take away their commissions any way they can. Women car sales agents must be self-centered and concerned with making money above all else. And, they are not particularly liked for this behavior. The public does not want to believe this about women, and men customers do not want to duel with women. They expect women to be easy to deal with, innocent and honest.

Because I also want women agents to be more honest, or at least to find that buying a car has become easier, like Diogenes, I am still looking for women sales agents. Two days ago (August 1999) I spoke with a woman who moved from Pennsylvania to Florida to sell cars. She lasted six months and is now back in her original line of work, the restaurant business. I asked her to tell me about her good and bad experiences. Her story sums up many women's opportunities in car sales:

> There are few good parts to selling cars, except maybe the opportunity to make better money than I did waiting tables. You can't be the same person you were before you went on the lot. I used to think I was tough and could handle anything. I learned different. Anybody that says they can sell and be honest is lying. Salespeople don't lie. They exaggerate the truth. I even acted different than I was. I had to be sweet and feminine to get help from salesmen. But I had to wear short, tight skirts to attract male customers. Women were threatened by me. Anyway, I got asked out more than I sold cars. I couldn't look people in the face and tell them they needed this car with all the extras. And some guys made $30,000 in four months.

EPILOGUE:

ON THE ROAD

It's a hard trail to blaze. To be a car saleswoman is to be a whore. You always carry your resume around in your mind, in your briefcase, in your car, in your back pocket, and you'll sleep with whoever is talking the most money. For $10,000 more, I'm your man [sic]. Till something goes wrong and it's time to go sleep over there.
 —Cathy, *moved twice in one year*

The person-by-person profiles that follow show that the car game is still the car game. Women seem to be getting better at it, but at what price?

Women

Andrea

Andrea had worked in car sales at one dealership for nine months at the time of our interview in 1988. When I called back a year later I was told by a salesman that she had "moved to Arizona and was looking for a job at dealerships there." I was unable to follow up.

Ann

When I first interviewed Ann in 1987, she had been with one dealership for twelve years. As she was my first formal interviewee, I kept in touch with her on a regular basis. In 1989, the original owner retired and his son took over running the agency. This caused Ann some uneasiness, but she said she would "try to stay." In 1990, at her request, Ann became a part-time employee. She was put on straight salary and made less money, but said the "trade off was worth it because I can spend more time with family, especially the grandchildren." In 1991 Ann was fired. The owner said she had "lost the fire to sell." Ann said this was not so and believes she was fired because she was "fully vested in a pension plan by the original owner and the new owner felt it cost the dealership too much to keep her." When I last saw Ann (1993) she was on straight salary, selling jewelry part time at an exclusive store in a north shore suburb of Chicago. She missed "the excitement of car sales" and had tried to get hired at a new dealership but no one would hire her because "of my age and the fact that I do

117

not want to put in those terrible hours anymore." Ann still felt she could "sell more cars at a good price in an hour than other people can in a week, but no one will give me the chance."

Arlene

Arlene had been in car sales for three years when I first interviewed her in 1988. Most of this time was spent at the same agency. She originally sold on the floor for eighteen months while helping out in finance and then was promoted to finance manager. In 1991, she tried working for another dealer in order to get shorter hours, but was unhappy there and returned to her original agency. At this time she was "content to remain there and put in the long hours." In 1993, I called the agency to see how Arlene was getting along and I was told by the receptionist, "She is still with us but was transferred to another of our dealerships." I was unable to locate her.

Barbara

Barbara was fired from her first dealership after three months. She was at her new dealership for a year and a half when I first interviewed her in 1990. She had been promoted to assistant finance manager. At my last call three years later, she was no longer with the agency.

Bernice

Bernice was at her dealership less than a year when I first interviewed her in 1987. She told me she had been fired from a previous car sales job after three months, and was "not doing well" at her current agency. A few months later, I spoke with Ann who said that Bernice was "fired shortly after I interviewed her and went to work at a third agency where she was also doing poorly." Ann kept in touch with Bernice for a while and in 1998 told me Bernice was "out of sales because she could not make a living at it."

Betsy

Betsy had been in car sales for over two years when I interviewed her in 1987. She had moved to a larger dealership after six months in order to make more money in hopes of owning her own store one day. She was still at that dealer four years later, but had not saved any money.

Bev

Bev was at her dealership for seven months at the time of our initial interview in 1988. When I called back a year later I was told by the receptionist, "Today is her day off." When I phoned back a week later, Bev was still "off."

Carol

Carol was at her dealership for over two years at the time of our interview in 1988. She had been promoted to finance manager. Although she complained of work overload, she was "glad to get experience in management," and said she was doing well. Three years later, she was still at her dealership but looking for a management position at other dealerships because "the higher pay and shorter hours they promised me here never materialized."

Carolyn

Carolyn was a finance manager for over five years, four of them at one agency where she had eventually been fired after a change in management. At the time of our interview, in 1990, she was finance manager at a new dealership for just over a year. When I called back two years later, she was still there and "doing okay."

Cathy

Cathy had worked in car sales for less than one year at the time of our initial interview in 1988. She left a previous dealer after a few months to move to this dealer because it was in a higher-class neighborhood. At my call back three years later, I was asked, "Who? She's not here."

Chris

At the time of our interview, in 1987, Chris had been at her agency for twenty-three months and was "looking for a new store." When I called back two years later she was gone. A co-worker in the office who remained in touch with Chris said she had "quit the business altogether."

Denise

Denise had been at her dealership for almost three years when I first interviewed her in 1987. Two years later she was still there and still living with her mother (Marcia) who sold cars at another agency owned by the same "family type" people.

Dorene

Dorene had been in car sales for fourteen years at the time of our interview in 1990. She had spent more than a year at her first job and then left to sell more expensive cars at the agency where I met her. She had been at this dealership for two years when it was taken over by new owners. The new owners convinced her to stay and made her sales manager. She said the money was "good." When I contacted the agency in 1995, she was still there.

Edith

Edith had worked in car sales for ten months at the time of our initial interview in 1994. At my call back a year later, I was told she had "moved to Florida six months ago."

Evelyn

At our first interview, in 1987, Evelyn had been at her dealership for four years. She had been made assistant to the finance manager after six months and finance manager six months after that. Two years later she was still at the dealership and "making good money."

Fran

Fran had been selling cars for thirteen years when I first interviewed her in 1990. She had started out selling Chevys and was now selling Cadillacs. She claimed to have made $160,000 one year when the market was "hot." Her ex-husband as well as her current boyfriend were car salesmen. When I phoned her three years after our first interview, she was still selling, but complained that business was not as good as it had been in the past. When I phoned the agency in 1999, to my amazement, Fran was still there.

Francis

When I first interviewed Francis in 1987, it was by phone at her home. She was between jobs and taking a rest from the "pressure of the business" after less than two years of quasi-administrative jobs aside from selling cars. She was, at this time, painting a friend's house to make money. Shortly after our first conversation she returned to car sales at a dealership where her friend Patsy worked. This was a smaller dealership with less pressure, but she also made less money. When I phoned there two years later, I was asked, "Is that a female or a guy? No, she's not here."

Gina

Gina left her first dealership after working there less than two years, for a chance to make more money at a higher-volume dealership. I first interviewed her in 1987, at her new place of business. She had been there for three years. She said she was happier there than she was student teaching in college. When I called back a year later she was still at work and enjoying it.

Helen

Helen owned and successfully operated a dealership in Michigan for ten years when I interviewed her in 1987. When I called two years later, she had opened a second agency in an adjacent county. I phoned the original dealership in 1999 and was told by a salesman that Helen is still managing the business and "our agencies are doing fine."

Ida

Ida was at her dealership for less than a year when I met her in 1986. During the next year she was promoted to finance manager. Because I bought a car from Ida, I enjoyed visiting the agency and watching her progress. However, when I came in for service in January 1990, the dealership had been sold to new owners. I was told, "No one by that name works here." Ida's friend Bill was also gone.

Isabel

Isabel had been at her dealership for nine months when I interviewed her in 1993. She was not doing well at sales and when I called back six months later, I was told she was "not with us any longer."

Jean

Jean was in the business for ten years at the time of our interview in 1987. Her first job as a sales representative lasted for two years until the agency closed. Soon after she married a part owner of another dealership and worked as finance manager there for six years until her divorce. She had been working for two years as finance manager at a new agency at the time of our interview. When I called back two years later, she was still with the agency but "looking for a job closer to my children."

Joan

Joan had been at her dealership for two weeks at the time of our interview in 1987. When I phoned her six months later to find out how she was doing, she said she was "considering going back to waitressing." I was told by the greeter whom I had befriended that Joan left soon after.

Joyce

Joyce, an ex-business major, had been at her dealership for two months when I interviewed her in 1988. She considered car sales to be her "new profession." Six months later she was no longer at the dealership.

June

June had been at her dealership for five years at the time of our interview in 1990. She preferred it over teaching pre-school and was looking forward to making this a "professional career." She had moved into leasing management when I called back a year later. Two years later I was told she was "no longer with our dealership."

Kate

Kate had worked in car sales for six months (three months each at two dealerships) at the time of our interview in 1987. I spoke with her six months later and she said she was "considering going into real estate" but was worried about the "time it would take to sell a house and make a commission." When I tried to contact her a year later, she was "no longer here."

Karen

Karen had been in car sales for eight years at the time of our initial interview in 1989. Her goal was stability at one dealership, preferably in a management position. She was a high earner and was being trained for management. A year later, Karen had not achieved her goal, even though she had given up custody of her children in order to work longer hours. She told me there was a "massive reorganization and many firings" since I last spoke with her. At that time she had been working in finance but was "put back on the floor." When I phoned her in 1995, she was still at the dealership and working as assistant sales manager.

Laurie

Laurie had been in car sales at her agency for three years at the time of our interview in 1988. Her father-in-law was the owner of the agency. After her first year in sales she was made finance manager. When I called back for a second interview, she told me her "husband had gone into partnership with his father in a newly opened agency." She said that she was "happy where she was, however, and wanted to stay there." Two years later, she was still there.

Leah

Leah had been in the business for eighteen months at the time of our first interview in 1987. She had sold at an adjacent agency (for six months) operated by the same owner of the dealership she was currently with. She had been transferred because "business was bad at the first dealership." When I contacted her six months later, she had just left sales to try her hand at office work in the billing department of the agency. Six months after that she was working in a public relations position, calling people to inquire about their satisfaction with service. When I visited the dealership six months later, a new woman was in her office and the dealership said Leah was "no longer with us." The dealership has since changed hands again.

Marilyn

Marilyn had been at her dealership for approximately one year when I first interviewed her in 1993. When I contacted her a year later, she was about to return to real estate sales, which she had done previous to car sales. She said she "liked it better."

Marsha

Marsha (Denise's mother) had been at her dealership for fifteen years when I interviewed her in 1987. During this time she saved enough money to buy a house for her and her daughter. When I called back a year later, Marsha said she was "more contented than before because the dealership is hiring more women and I don't feel as isolated." Two years after that I visited Marsha and she was still working and "looking forward to paying off her mortgage and retiring."

Martha

Martha was in car sales for six months when I first interviewed her in 1987. She had been fired after three months from her first dealership. When I phoned the new dealership a year later I was told she was "no longer with us."

Milly

Milly had worked in car sales for eight years at the time of our interview in 1999.

Nancy

Nancy had been in car sales for six months when I first interviewed her in 1987. She had not made many sales during this time and when I phoned back to check on her progress a year later, I was told, "There is no one here by that name."

Nina

Nina had been at her agency for five years when I first interviewed her in 1988. She said she had "stayed even when the dealership changed owners after two years." When I phoned back a year later she was still on the job and "loving it."

Nora

Nora had been in car sales at one dealership for ten years when I first interviewed her in 1987. When I visited a year later she had been promoted to finance manager. In April of the following year I saw a picture of Nora in a car advertisement in a local paper. She was working at a higher-volume dealership as a sales manager. When I visited her there, she told me there was a "shake-up" (management passed from father to son), and she was put "back on the floor," so she decided to leave. Two years later, she was still at the new agency and still complaining that "cars are not selling and money isn't that good."

Norine

Norine had been at her agency for three years and had just been made finance manager at the time of our interview in 1994. When I called back a year later she was still there and happy with her job.

Oprah

Oprah had been at the dealership for approximately two years as assistant to the finance manager when I interviewed her in 1988. Although she had a husband and three pre-teen children, she had worked out a system to enable her to work the long hours and she said her dealership was "extremely stable." She was still there two years later and had been made finance manager.

Patsy

Patsy had been at the dealership for twelve years when I interviewed her in 1987. She worked on the floor for nine years and was then promoted to sales manager. She did not want to move from her agency, but when I phoned her back a year later, she said a "new guy, Larry, was brought in to share the position with me." She suspected he was "paid more," and felt "employees and management prefer to deal with him more often." When I phoned back the following year, she was still at work and still dividing the position, but this time with a different man.

Pearl

Pearl worked for thirteen years at a dealership in all areas but sales. She was in sales for six months and got fired. I interviewed her in 1994, after she was fired. She did not go back to working in car sales, although she still enjoys telling stories about her work there. As of 1999 she was managing a women's clothing store.

Phyllis

The second time I bought a car during this research, it was from Phyllis who had been at her dealership for four years at the time of the sale in 1990. I returned to the agency when I found out I had been given incorrect information about the history of the car, but Phyllis talked her way out of the problematic situation and we remained friendly. When I returned for service work a year later she had been promoted to finance manager. The next time I returned for service work, there was a new woman in Phyllis's office. I asked her where Phyllis was and she said there was a "big shake-up and Phyllis was asked to step down."

Renita

Renita had been in car sales at the same "top of the line" dealership selling Rolls Royces for seven years when I interviewed her in 1995. She had married and divorced men in the business and when I visited her two years later she was still there "enjoying myself." In 1999 I phoned the agency and Renita was still working there.

Rita

Rita had been in car sales at the same agency for approximately two years when I interviewed her in 1988. Even though she had recently had a baby, she loved the work. Two years later she was still at the dealership and finding it "easier now that the baby is older."

Roberta

Roberta had been selling cars for two years at the time of our interview in 1987, but had only recently taken the job at this dealership. She was twenty-four years old and yet doing quite well. When I visited her a year later, she was still there and said she was "one of the top sellers at the dealership."

Sally

Sally, a true pioneer, had been in car sales for thirty years. She stayed with the same manufacturer for eighteen years, even though she moved to different unrelated agencies that sold the product. She had been at her dealership for nine years at the time of our interview in 1987. At my call back two years later, she was still there but "thinking about retirement."

Sarah

Sarah had been selling cars for fifteen months at the dealership when I interviewed her in 1988. She was dating Mark, a sales agent. She said, "Mark's support is what keeps me here." When I phoned back a year later, she was "no longer with us." Mark was still with the agency but said he "doesn't see Sarah any longer."

Sonja

Sonja was interviewed in 1999. She had been at her dealership for six months.

Vita

Vita had been at her agency for four years, more than three of them as a clerk in the office. She asked to try sales when she compared her salary with that of the saleswomen and thought, "I can do that." Her main concern at the time I interviewed her in 1989 was stability. Two years later she was still at her agency and "doing fine."

Wendy

Wendy had been in car sales for less than a year when I interviewed her in 1988. She worked long hours and wanted to relax in bars with the men after work but was discouraged from doing so by her manager. She did not seem happy at the time of our interview and when I phoned back a year later John (the manager) said, "Wendy was working in a restaurant last I heard."

Yolanda

Yolanda had been in sales for a little over a year at the time of our interview in 1994. Although she felt she could succeed at the work, her main complaint was the harassment she received from salesmen. She was not at the dealership when I phoned a year later.

Men

Bill

Bill had been in car sales and with the same agency for approximately eighteen months when I interviewed him in 1987. He was dating Ida, whom I bought a car from when I first began research on car saleswomen. Periodically, when I came in for service, I would try to check in with both of them. They even drove me home once when my car was in the shop for the day. Bill and Ida said they thought of the dealership as "family" and stayed there until 1990 when the dealership was sold. I could not locate them.

Chad

Chad was selling cars for a little over a year, at the same dealership, when I first interviewed him in 1987. When I phoned the agency a year later they said, "Who? There's no one here by that name?"

Christopher

Christopher was not a car salesman. He was a beginning chemical salesman whom I interviewed for comparison purposes during 1987-88. He left the field after a year or so. Because he had allowed me to call him at home I have kept in contact with him over the years. By 1992 he was out of sales altogether, and had moved to California. He now (1999) makes commercials and has gotten some acting parts on sit-coms. He recently told me that a West Coast friend of his, doing "door-to-door cold sales for straight commission, was fired although she thought she was doing a good job." He said this parallels his experience in chemical sales where the "management takes over the new accounts a salesperson has opened and fires them in order to pay less commission."

Don

Don was new at sales and had been at the dealership for three months when I interviewed him in 1987. When I phoned back six months later, he was "off

today." He was also not there the next time I called and no one knew who he was when I phoned a year later.

Frank

Frank was in car sales for fifteen years when I interviewed him in 1987. He had been hired at the dealership adjacent to Ida's two years previous as a sales manager. I had no introduction and no set appointment to meet with him at the time. I just wandered in and he approached me and was willing and anxious to talk about his sales philosophy. When I phoned back a year later he was gone. The new sales manager said he had "no idea who or where Frank was."

Gary

Gary, twenty-four-years-old, was one of the youngest of my interviewees. He had been at his dealership for three months at the time of our interview in 1988. He had stayed only three months at his previous dealership. When I phoned back six months later, I was told he was "no longer with us."

George

George had been selling at a family owned dealership for eight years when I interviewed him in 1988. He liked sharing his ideas on how to sell, "get them in a loaded car and put on the pressure." When I phoned back a year later, the greeter said, "George is busy with a customer, can he call you back?" And, he did.

Harvey

Harvey had been in car sales for two months at the time of our interview in 1987. He was twenty-five-years-old and very positive and excited about the work and his camaraderie with co-workers. When I phoned back a year later, I was told, "Who, nah, he's not here."

Irv

Irv, seventy-seven-years-old, worked in car sales for thirty years, twenty-five of them as a sales manager, before retiring. He says he worked at "about eight agencies during his sales career." We met in Pennsylvania in 1992 and we still discuss car sales. He said, "I used to call it 'easy money' because on some deals the money was so good and I didn't feel like I did much to make it." Yet he also said, "I couldn't work the long hours or compete the way I used to, so I quit. I sold furniture for a while."

Jim

When I interviewed Jim, in 1987, he was twenty-four-years-old and had been in car sales for three years. I asked him why he chose this career at such a young age and he said, "fast money." He liked car sales and was very aggressive at it. When I phoned back a year later, Jim was still there and said he was the "top salesperson" that year.

Joe

When I interviewed Joe in 1993, he had been selling cars for eight months at the same dealership. He was not selling many cars, not happy with the work, and talking about leaving. When I called back six months later, he was "not here." He had given me his home phone, so I was able to locate him and found he was selling electronic appliances at a discount store where the prices were fixed. He said, "The money's not great, but I feel better about myself."

John

John, Wendy's general manager, had been in car sales for eighteen years at the time of our interview in 1987. He said he had "worked at a lot of dealerships and knew when to move, like if things start to go bad, and certain models aren't selling that year." Yet, he had "two kids, one in high school and my wife doesn't want to move around." When I called back two years later, he was still general manager.

Larry

Larry was in car sales for eight years. He was at his present agency for about a year at the time of our interview in 1988. He was hired to share the sales management position with Patsy. He said he had worked at two agencies as a sales manager before coming to this one.

Mark

Mark was in car sales for four years at the same dealership at the time of our interview in 1988. He was dating Sarah at the time. He was still at the dealership a year later, but Sarah was gone.

Marvin

Marvin was in car sales for ten years and a sales manager at the time of our interview in 1989. He had worked at four dealerships and was hoping he could

remain stable at his new agency. When I phoned back a year later to ask if Marvin still worked there, I was told, "No, he don't."

Mike

Mike had sold cars in one capacity or another for fifteen years and had recently given up selling cars. I was introduced to him by a neighbor who knew I was looking for car salespeople who had left the field. When I interviewed Mike in 1987, he had just opened his own business in a related field, selling credit to car dealerships, and was glad to tell me about his new enterprise. When I called the agency in 1999, there was no such business at that number.

Pete

Pete had been selling cars for seven years. He had been a sales manager, at the dealership when I interviewed him in 1988, for the past four years. He liked his job and was a hard liner when it came to firing people who did not produce quickly. When I phoned back a year later, he was still with the agency.

Rod

Rod, Dorene's general manager, was in car sales for thirteen years. At the time of our interview, in 1990, he had been general manager of the dealership for eight years. Before that he had "searched for a place that was stable, floating from agency to agency." When I phoned back a year later he was still with the agency and positive about the future.

Roger

Roger was a salesman at a "mega" mall store when I interviewed him in 1999. He had been at the dealership for six months.

Scott

Scott had been in car sales for six months at the time of our interview in 1994. He had been at his previous agency for three months before being fired. When I phoned back a year later, I was told, "We have no one by that name that I know of."

Tim

Tim had been at his dealership for less than a year at our interview in 1999.

Vic

Vic, Patsy's general manager, had been in car sales for fifteen years. Ten of those years were as sales manager at the agency where we interviewed in 1987. When I phoned back a year and then two years later, he was still there.

Vincent

Vincent had been a salesman at Helen's dealership for four years when I interviewed him in 1999.

Will

Will was in car sales for five months at the time of our interview in 1987. When I phoned back a year later he was still at the dealership. Two years later, he was still at the dealership.

APPENDIX:

FIELDWORK

I collected the data for this longitudinal study from in-depth interviews and observations of forty-nine women (car sales agents and managers) and twenty-three men (car sales agents and managers). I visited them at car agencies, restaurants, and home sites in Chicago, New York, and Pennsylvania over a period of twelve years from 1987 through 1999. I endeavored to make the women in my sample representative of the population of women car sales agents and managers with respect to age, race, marital status, and type of dealership represented. The women respondents ranged in age from twenty-three to sixty with an average age of thirty-five. They had been in car sales, but not necessarily with the same dealership, from as little as two weeks to as long as twenty-five years. The average was just over three years. The men respondents were similar in age range (twenty-four to sixty years of age) and length of time spent in car sales (three months to thirty years). Although the data are largely based on retrospective interviews, people at the beginning of their careers told stories similar to those told by experienced workers about their initial interactions. I, therefore, did not observe a cohort effect in which newcomers behaved differently from pioneering women when they began.

Throughout the book, I chose to use the title *sales agent* when speaking about sales workers. Men and women sales workers' business cards give them titles such as sales consultant, sales representative, sales and leasing agent, fleet and leasing manager, new car sales consultant, finance and insurance manager, and so on. There is so much movement in car sales that workers change titles on a regular basis. Therefore, a person may be a sales agent at one time and a leasing manager at another. In cases where I interview a worker who is in a management position at the time of the interview, I make reference to this title. If I do not use woman or man before agent, I wish the title to be inclusive of both sexes. The respondents call other workers salesmen, saleswomen, salespersons, and other titles when speaking about them. I have not altered their words. The names of respondents are not their real names unless so indicated. The locations of dealerships are accurate, but I hope not specific enough to be recognized. The names of dealerships are false. The types and makes of automobiles discussed are real.

I based my research on qualitative methods and experiences I had read about and were invaluable to me in solving problems I encountered along the way.[1] I did not try to sell cars as others suggested I do, but I thought about it. Instead, I "hung out" at car lots, sat in offices of sales agents, listened in on

calls, and watched interactions between sales agents, management, and customers, in some instances posing as a customer. My first respondent was a friend of a colleague; she suggested I might find it easier to begin my study by interviewing a woman who lived in my neighborhood and was of my same ethnic background. Additional informants were selected through a snowball sample: interviewees would suggest dealerships where they knew someone I could interview next. They would often call ahead and arrange an introduction. The interviews lasted from one to two hours and were taped and transcribed verbatim. I coded them according to key concepts that emerged from the interviews. I wrote interpretive comments following each interview. In two instances, I became a "real" customer out of necessity because I needed a car, buying automobiles from women who did not know I was doing research until after the purchases were completed. An additional informant was a personal friend who began selling on a commission basis about the same time I started to do my research and who spoke with me about his progress on a daily basis. In 1991, I was hired as assistant professor of sociology at the University of Pittsburgh at Bradford, Pennsylvania. Once settled into my new position, I began to interview sales agents from this area. I was excited about the possibility of comparing and contrasting stories from such differing localities as Illinois, Pennsylvania, and bordering areas such as New York. I continued to follow the careers of my initial respondents via phone and when on trips back to Chicago.

In order for me to understand what was happening in car sales and to see how the culture compared with the descriptions of the cultures of other occupations, I had to immerse myself in the world of car sales. It is difficult to interview car sales agents. Most agents do not want to meet on their time off or at their homes. Free time is limited and very valuable to them and they do not want to spend it talking to strangers about their work. Home is a very private place to them where they can and need to unwind. Many single persons have unlisted phone numbers. Meeting at dealerships was also difficult because there is little privacy and managers and owners could hear everything we said; so openness would be difficult and confidentiality hard to maintain. When I went to an agency for an interview, I needed much patience and perseverance. I was either waiting for their customers to leave or for sales agents to find time to see me between walk-ins and phone calls. Even when I had appointments, I got stood up. Respondents did not come to prearranged lunch dates or were absent from work at the time and day they had agreed on for the interview.

Going into situations where workers engage in activities that make planning precarious, as in sales, where a serious customer may unexpectedly return, forces the interviewer to spend valuable time waiting. Even if one follows respondents around, it is difficult to find a block of time to engage in more involved conversation. It is important to be careful that the researcher's activities do not interfere with the respondents' need to make money. I tried to stay out of the way when agencies were busy. I met respondents during their slow times, such as early mornings, in the middle of the week, early in the month, during slower months or days when the weather was bad. I waited around if they had customers and I came back again and again if they got too busy to see me. I

chased one woman, Leah, for three months before getting an interview. Once she stood me up in a restaurant and I ended up eating an unwanted lunch. The next time she stood me up at her place of work. Finally, I went to her agency and sat there waiting for hours until she found time for me. During our interview, she told me I was a "super sales person" because I got her to talk with me when she did not want to and had already stood me up twice.

Yet, I felt oddly alienated during interviews. In a sense, I felt this way because I was not a car sales agent and I knew very little about this world. I also looked out of place because I dressed differently from agents. Most agents were "dressed for success" in the latest business career apparel, while I wore the thrift store clothes acceptable and typical for graduate students. I felt, much as other field workers before me, unfamiliar with the social world under investigation and a resulting sense of edginess, uncertainty, discomfort, and anxiety. Eventually, I found that informants did not expect me to be just like them. In fact, they were interested and pleased to find me different, as other researchers had claimed would happen. For example, my first informant Ann phoned me at home after reading an article about my research in *Today's Chicago Woman*. Accompanying the article was an ad for her agency carrying her picture as a top truck sales agent. She was pleased for both of us.

In addition, in order to get interviews, I had to convince agents that I was not going to get them in trouble with their bosses and that I was not out to write an exposé about crooked dealing at their agency. Twice I was turned down because management did not allow interviews due to previous bad press releases in local papers. To get around this, I got respondents to call agents they knew at other agencies and set up introductions for me. That way the current informant would explain that I seemed okay and had promised not to use names of sales workers or agencies in my study. Because many of the sales agents I interviewed knew each other, I was careful not to discuss information I had received from one with another. Even though I was let in on insider stories about agents and managers, I did not pass this gossip on. Two articles were published using data from this study. Because the community of car sales in the Chicago area is a small world where people all know each other, women stand out, and tales of their personal lives and behavior as well as successes and failures spread quickly. I have, therefore, at times, taken liberties with details and used different names at different times when attributing quotes.

Some people's stories of their activities differed from what I had witnessed or heard from other people. For example, I overheard a customer angrily telling Dorene, "You really worked me over. Forget it!" He then left the dealership. I asked Dorene what had occurred in the interaction and she replied that she had been very "fair" with the customer, going out of her way to get him the "best deal possible." Dorene was an aggressive closer who made high profits on deals. She felt this behavior was sensible fair business practice. However, it was an area of conflict for other sales agents who felt this was "unfair" practice. Verbally, this problem manifested itself in the use of aggressive and violent language. The talk at dealerships was peppered with the words from movies of gangster wars. Sales agents fought with owners and management, with each

other, and with customers, sometimes blaming each other for wrong doing, and sometimes bragging. When experienced sales agents sold to customers, they said they "worked 'em over" and then "put 'em away" or "did them in." After selling a car for a good profit, they said the person "came out of the ether." And, co-workers were said to "get in your pants" if not watched.

I did not dismiss statements by members of the group under study as valueless, because these statements told me about ideals and notified me about problems in the setting. Even a seriously defective statement of an event provided useful evidence if the statement was seen as coming from a perspective which was a function of the person's position in the group at the time. Yet language was problematic; words did not have the same meaning in the culture of car sales as they did in my world. The culture's spoken words were true, but only if I looked at them from the view of the inhabitants. In order to understand what the informants were saying about themselves, however, I had to study the system as a whole, complete with politics, power, and economic structure. For this reason, if sales agents said, "I am a professional," they defined "professional" according to the rules of their system. Once I began to understand this system, I learned that agents' stories coincided with their positions. Newcomer's perspectives of occurrences were similar to those of dropout's picture of events, whereas experienced and successful people had socialized and thereby different perspectives and realities. For example, most newcomers and dropouts were angry at having to pressure people into high-priced cars and preferred to sell at lower prices. Experienced agents, by contrast, considered it imperative to make as much money as possible, thereby being loyal to the dealership.

Notes

1. For example see Norman Denzin and Yvonna S. Lincoln, eds., *Handbook of Qualitative Research* (Thousand Oaks, Calif.: Sage Publications, 1994); Everett Hughes, *The Sociological Eye* (Chicago: Aldine, 1971); Barney G. Glaser and Anselm L. Strauss, *The Discovery of Grounded Theory: Strategies for Qualitative Research* (Chicago: Aldine, 1967). For examples of problems that emerge and how to overcome them, see William Shaffir, Robert Stebbins, and Allan Turowetz, eds., *Fieldwork Experience* (New York: St. Martin's Press, 1980); and Robert M. Emerson, ed., *Contemporary Field Research* (Boston, Mass.: Little Brown, 1983).

REFERENCES

Becker, Howard S. 1963. *Outsiders: Studies in the Sociology of Deviance.* New York: Free Press.

Becker, Howard S., and James Carper. 1956. "The Development of Identification With an Occupation." *American Journal of Sociology* (61): 289-298.

Benson, Susan Porter. 1986. *Counter Cultures.* Urbana, Ill.: University of Illinois Press.

Berch, Betina. 1982. *The Endless Day: The Political Economy of Women and Work.* New York: Harcourt, Brace, Jovanovich, Publishers.

Bernard, Jessie. 1964. *Academic Women.* University Park: Pennsylvania State University Press.

Blum, Lawrence A. 1980. *Friendship, Altruism, and Morality.* Boston: Routledge and Kegan Paul.

Bradley, Harriet. 1989. *Men's Work, Women's Work.* Minneapolis: University of Minnesota Press.

Braverman, Harry. 1974. *Labor and Monopoly Capital.* New York: Monthly Review Press.

Browne, Joy. 1973. *The Used Car Game: A Sociology of the Bargain.* Lexington, Mass.: Lexington Books.

Bucher, Rue, and Joan G. Stelling. 1977. *Becoming Professional.* Beverly Hills, Calif.: Sage Publications.

Carter, Michael, and Susan Boslego Carter. 1981. "Women's Recent Progress in the Professions or Women Get a Ticket to Ride After the Gravy Train Has Left the Station." *Feminist Studies* 7:476-504.

Chodorow, Nancy. 1978. *The Reproduction of Mothering.* Berkeley: University of California Press.

Cockburn, Cynthia. 1991. *In the Way of Women: Men's Resistance to Sex Equality in Organizations.* Ithaca, N. Y.: ILP Press.

——. 1983. *Brothers: Male Dominance and Technological Change.* London: Pluto Press.

Colwill, Nina. 1993. "Women in Management: Power and Powerlessness." In B. C. Long and S. E. Kahn, eds., *Women, Work and Coping,* pp. 73-89. Montreal Buffalo: McGill-Queens University Press.

Connelly, Maureen, and Patricia Rhoton. 1988. "Women in Direct Sales." In A. Statham, E. M. Miller, and H. O. Mauksch, eds., *The Worth of Women's Work,* pp. 245-264. Albany, N.Y. : State University of New York Press.

Coser, Rose. 1960. "Laughter Among Colleagues." *Psychiatry* 23: 81-85.

Crosby, Fay J. 1991. *Juggling: The Unexpected Advantages of Balancing Career and Home for Women and Their Familes.* New York: Free Press.

Danco, Katy. 1981. *From the Other Side of the Bed: A Woman Looks at Life in the Family Business.* Cleveland, Ohio: Center for Family Business University Press.

Davis, Fred. 1959. "The Cabdriver and His Fare: Facets of a Fleeting Relationship." *American Journal of Sociology* 65: 158-165.

DeLorenzo, Matt. 1988. "Recession on Way, Analyst Says." *Automotive News.* May 2 n5231 1: 54.

Denzin, Norman K. 1978. *The Research Act: A Theoretical Introduction to Sociological Methods.* New York: McGraw Hill.

Denzin, Norman K. and Yvonna S. Lincoln, eds. 1994. *Handbook of Qualitative Research.* Thousand Oaks, Calif.: Sage Publications.

Detman, Linda A. 1990. "Women Behind Bars: The Feminization of Bartending." In Barbara Reskin and Patricia Roos, eds., *Job Queues, Gender Queues:Explaining Women's Inroads Into Male Occupations,* pp.241-255 Philadelphia: Temple University Press.

Deutsch, Morton. 1958. "Trust and Suspicion." *Journal of Conflict Resolution* 4: 165-179.

Dex, Shirley. 1985. *The Sexual Division of Work: Conceptual Revolutions in the Social Sciences.* New York: St. Martin's Press.

Ditton, Jason. 1977. "Learning to Fiddle Customers: An Essay on the Organized Production of Part-Time Theft." *Sociology of Work and Occupations* 4: 427-450.

Donovan, Frances R. 1974. *The Saleslady.* New York: Arno Press.

Dunn, Dana. 1997. *Workplace/Women's Place.* Los Angeles, Calif.: Roxbury Publishing Co.

Edwards, Richard. 1979. *Contested Terrain: The Transformation of the Workplace in the Twentieth Century.* New York: Basic Books.

Eisenberg, Susan. 1998. *We'll Call You if We Need You: Experiences of Women Working Construction.* Ithaca, N.Y.:ILR Press.

Ellman, Edgar S. 1963. *Managing Women in Business.* Waterford, Conn.: National Foremans' Institute-Bureau of Business Practice National Sales Development Institute.

Emerson, Robert, ed. 1983. *Contemporary Field Research.* Boston: Little Brown.

Epstein, Cynthia Fuchs. 1988. *Deception Distinctions: Sex, Gender and the SocialOrder.* New Haven: Yale University Press.

——. 1993. *Women in Law.* Urbana: University of Illinois Press.

Erikson, Erik. 1968. *Identity: Youth and Crisis.* New York: Norton.

Farberman, Harvey. 1975. "A Criminogenic Market Structure: The Automobile Industry." *Sociological Quarterly* XVI: 438-457.

Fine, Gary Alan. 1996. *Kitchens: The Culture of Restaurant Work.* Berkeley: University of California Press.

Flink, James J. 1975. *The Car Culture.* Cambridge, Mass.: MIT Press.

Fox, Mary Frank and Sharlene Hesse-Biber. 1984. *Women at Work.* Palo Alto, Calif.: Mayfield Publishing Company.

Freidson, Eliot. 1986. *Professional Powers: A Study of the Institutionalization of Formal Knowledge.* Chicago, Ill.: University of Chicago Press.

Garson, Barbara. 1977. *All the Livelong Day: The Meaning and Demeaning of Routine Work.* New York: Penguin Books.

Geis, Gilbert, Robert F. Meier, and Lawrence Salinger, eds. 1995. *White Collar Crime.* New York: Free Press.

Gerson, Kathleen. 1993. *No Man's Land: Men's Changing Commitments to Family and Work.* New York: Basic Books.

——. 1985. *Hard Choices: How Women Decide About Work, Career, and Motherhood.* Berkeley: University of California Press.

Gerstel, Naomi, and Harriet Engel Gross. 1987. *Families and Work.* Philadelphia: Temple University Press.

Gilligan, Carol. 1982. *In a Different Voice.* Cambridge, Mass.: Harvard University Press.

Glaser, Barney G., and Anselm L. Strauss. 1967. *The Discovery of Grounded Theory: Strategies for Qualitative Research.* Chicago: Aldine.

Glazer, Nona Y. 1991. "Between a Rock and a Hard Place: Women's Professional Organizations in Nursing and Class, Racial and Ethnic Inequalities." *Gender and Society.* 5(3): 351-372.

Goffman, Erving. 1961. *Encounters.* Indianapolis: Bobbs-Merrill.

——. 1959. *The Presentation of Self in Everyday Life.* Garden City, N.Y.: Doubleday and Company.

Gold, Raymond L. 1964. "In the Basement: The Apartment Building Janitor." In Peter L. Berger, ed., *The Human Shape of Work: Studies in the Sociology of Occupations,* pp 1-49. New York: Macmillan.

Haas, Jack. 1977. "Learning Real Feelings: A Study of High Steel Ironworker's Reactions to Fear and Danger." *Sociology of Work and Occupations* 4: 147-170.

Habenstein, Robert. 1963. "Critique of a 'Profession' as a Sociological Category." *Sociological Quarterly* 4: 291-300.

Hall, Elaine J. 1993. "Waitering/Waitressing: Engendering the Work of Table Servers," *Gender and Society* 7(3): 329-346.

Harlan, Anne, and Carol L.Weiss. 1980. "Career Opportunities for Women Managers." In C. Brooklyn Derr, ed., *Work, Family and the Career: New Frontiers in Theory and Research.* Pp. 188-199 New York: Praeger.

Hennig, Margaret, and Ann Jardim. 1977. *The Managerial Woman.* Garden City, N.Y.: Anchor Press.

Hochschild, Arlie Russell. 1997. *The Time Bind: When Work Becomes Home and Home Becomes Work.* New York: Metropolitan Books.

——. 1983. *The Managed Heart: Commercialization of Human Feelings.* Berkeley: University of California Press.

Howe, Louise Kapp. 1977. *Pink-Collar Workers: Inside the World of Women's Work.* New York: G. P. Putnam and Sons.

Howton, F. William, and Bernard Rosenberg. 1965. "The Salesman: Ideology and Self-Image in a Prototypic Occupation." *Social Research* 32: 276-298.

Hughes, Everett C. 1971. *The Sociological Eye.* Chicago: Aldine.

——. 1962. "Good People and Dirty Work." *Social Problems* (10) 3-11.

Hunt, Pauline. 1980. *Gender and Class Consciousness.* New York: Holmes and Meier Publishers.

Jackall, Robert. 1988. *Moral Mazes: The World of Corporate Managers.* New York: Oxford University Press.

Kahn-Hut, Rachael and Arlene K. Daniels, eds., 1982. *Women and Work: Problems and Perscpectives.* New York: Oxford University Press.

Kanter, Rosabeth. 1977. *Men and Women of the Corporation.* New York: Basic Books.

Kelly, Rita Mae. 1997. "Sex-Role Spillover: Personal Familial and Organizational Roles." In Dana Dunn, ed., *Workplace/Women's Place*, pp. 150-160. Los Angeles, Calif.: Roxbury Publishing.

Kendall, Diana. 1999. "Sociology In Our Times." Belmont, Calif.: Wadsworth Publishing Company.

Koller, Marvin R. 1988. *Humor and Society: Explorations in the Sociology of Humor.* Houston: Cap and Gown Press.

Leidner, Robin. 1993. *Fast Food, Fast Talk: Service Work and the Routinization of Everyday Life.* Berkeley, Calif.: University of California Press.

——. 1991. "Serving Hamburgers and Selling Insurance: Gender, Work and Identity in Interactive Service Jobs." *Gender and Society.* (5): 154-177.

Lopata, Helena, Cheryl Miller, and Debra Barnewolt. 1986. *City Women in America.* New York: Praeger.

Lorber, Judith. 1989. "Trust, Loyalty and the Place of Women in the External Organization of Work." In Jo Freeman, ed., *Women: A Feminist Perspective*, pp. 370-378. Palo Alto, Calif.: Mayfield Publishing Company.

Lundstrom, William J., and Neil Ashworth. 1983. "Customers' Perceptions of the Saleswoman: A Study of Personality, Task and Evaluative Attributes by Respondent Location and Gender." *Journal of the Academy of Marketing Science* 2: 114-122.

Lunneborg, Patricia. 1990. *Women Changing Work.* New York: Bergin and Garvey Publishers.

Martin, Norman. 1999. "Look Who's Talking: Saturn's Cynthia Trudell." *Automotive Industries* (Feb.) v179i2p125(1).

Martin, Susan Ehrlich. 1989. "Sexual Harrasment: The Link Joining Gender Stratification, Sexuality, and Women's Economic Status." In Jo Freeman, ed., *Women: A Feminist Perspective.* Pp. 22-46. Mountain View, Calif.: Mayfield Publishing Company.

Martin, Susan Ehrlich, and Nancy C. Jurik. 1996. *Doing Justice, Doing Gender: Women in Law and Criminal Justice Occupations.* Thousand Oaks, Calif.: Sage Publications.

Mauser, Ferdinand. 1973. *Salesmanship: A Contemporary Approach.* New York: Harcourt Brace Jovanovich.

Mayer, David and Herbert M. Greenberg. 1964. "What Makes a Good Salesman." *Harvard Business Review* (July/August): 119-125.

McMurray, Robert N. 1961. "The Mystique of Super-Salesmanship." *Harvard Business Review* (March/April):113-122.

McShane, Clay. 1994. *Down the Asphalt Path: The Automobile and the American City.* NewYork: Columbia University Press.

Miller, Stephen J. 1964. "The Social Basis of Sales Behavior." *Social Problems* 12: 15-24.

Mills, C. Wright. 1959. *The Sociological Imagination.* New York: Oxford University Press.

——. 1951. *White Collar: The American Middle Classes.* New York: Oxford University Press.

Mitchell, Garry. 1991. *The Heart of the Sale: Making the Customer's Need to Buy the Key to Successful Salesmanship.* New York: American Marketing Association.

Mulkay, Michael. 1988. *On Humor: Its Nature and Its Place in Modern Society.* New York: B. Blackwell.

Oakes, Guy. 1990. *The Soul of the Salesman.* Atlantic Highlands, N.J.: Humanities Press International.

Oakley, Ann. 1974. *The Sociology of Housework.* New York: Random House Publishers.

Oda, Massami. 1983. "Predicting Sales Performance of Car Salesmen by Personality Traits." *Japanese Journal of Psychology* 54: 73-80.

O'Farrell, Brigid. 1982. "Women in Non-Traditional Blue-Collar Jobs in the 1980s: An Overview." In Phyllis Wallace, ed., *Women in the Workplace,* pp. 135-165. Boston, Mass.: Auburn House.

Paules, Greta Foff. 1991. *Dishing It Out: Power and Resistance Among Waitresses in a New Jersey Restaurant.* Philadelphia: Temple University Press.

Pavalko, Ronald M. 1988. *Sociology of Occupations and Professions.* Itasca, Ill.: F. E. Peacock Publishers.

Pevin, Dorothy. 1968. "The Use of Religious Revival Techniques to Indoctrinate Personnel: The Home-Party Sales Organization." *Sociological Quarterly* 9: 97-106.

Phipps, Polly A. 1990. "Occupational Resegregation Among Insurance Adjusters and Examiners." In Barbara Reskin and Patricia Roos, eds., *Job Queues, Gender Queues: Explaining Women's Inroads Into Male Occupations,* pp. 225-240. Philadelphia: Temple University Press.

Pothier, Dick. 1974. "Down with Niceness! Sell That Insurance." *Philadelphia Inquirer* (October 1) 1C.

Preston, Jo Anne. 1995. "Gender and the Formation of a Women's Profession: The Case of Public School Teaching." In Jerry A. Jacobs, ed., *Gender Inequality at Work,* pp. 379-407. Beverly Hills, Calif.: Sage Publications.

Prus, Robert. 1989a. *Pursuing Customers: An Ethnography of Marketing Activities.* Newbury Park, Calif.: Sage Publications.

——. 1989b. *Making Sales: Influence as Interpersonal Accomplishment.* Newbury Park, Calif.: Sage Publications.

Quigley, T. R. 1994. "The Ethical and the Narrative Self." *Philosophy Today* 38: 1.

Rae, John. 1965. *The American Automobile: A Brief History.* Chicago: University of Chicago Press.

Rayes, George. 1988. "New People Need to be Well-Trained: Structured Programs Teach the Right Habits." *Pro Chevrolet Magazine.* August 1:21.

Reardon, Kathleen Kelly. 1995. *They Don't Get It, Do They?* Boston, Mass.: Little Brown.

Reskin, Barbara, and Irene Padavic. 1994. *Women and Men at Work.*Thousand Oakes, Calif.: Pine Forge Press.

Rey, William Lloyd. 1986. "The Influence of Gender Related Effects Upon Buyers' Perceptions of Saleswomen in a Traditionally Male Dominated Occupation." Ph. D. dissertation, University of Mississippi.

Ritzer, George. 1972. *Man and His Work: Conflict and Change.* New York: Appleton-Century-Crofts.

Rolls, Hon. Charles S. 1911. "Motor Vehicles, Light." In *Encylopaedia Britannica.* New York: Encyclopaedia Britannica.

Roos, Patricia A. 1985. *Gender and Work.* Albany: State University of New York Press.

Rosenberg, Janet, Harry Perlstadt, and William R. F. Phillips. 1993. "Now That We Are Here: Discrimination, Disparagement and Harassment at Work and the Experience of Women Lawyers." *Gender and Society.* 7 (3) 415-433.

Roth, Charles, and R. Alexander. 1983. *Secrets of Closing Sales.* Englewood Cliffs, N. J.: Prentice Hall.

Rothman, Robert A. 1987. *Working: Sociological Perspectives.* Englewood Cliffs, N. J.: Prentice Hall.

Rustad, Michael L. 1984. "Female Tokenism in the Volunteer Army." In Frank Fischer, and Carmen Sirianni, eds., *Critical Studies in Organization and Bureaucracy,* pp. 269-286. Philadelphia: Temple University Press.

Scharff, Virginia. 1991. *Taking the Wheel: Women and the Coming of the Motor Age.* Albuquerque: University of New Mexico Press.

Schroedel, Jean Reith. 1985. *Alone in a Crowd: Women in the Trades Tell Their Stories.* Philadelphia: Temple University Press.

Schwartz, Eleanor Brantley. 1971. *The Sex Barrier in Business.* Atlanta: Georgia State University Press.

Scull, Penrose. 1967. *From Peddlers to Merchant Princes: A History of Selling in America.* Chicago: Follett Publishing Company.

Shaffir, William, Robert Stebbins, and Allan Turowetz, eds. 1980. *Fieldwork Experience.* New York: St. Martin's Press.

Shorris, Earl. 1994. *A Nation of Salesmen: The Tyranny of the Market and the Subversion of Culture.* New York: W. W. Norton.

Simmel, Georg. 1978. *The Philosophy of Money.* Boston: Routledge and Kegan Paul.

Spear, Elizabeth, Public Relations Coordinator. 1999. National Automobile Dealers' Association. Phone Conversation, May 27.

Spradley, James P., and Brenda J. Mann. 1975. *The Cocktail Waitress: Woman's Work in a Man's World.* New York: John Wiley and Sons.

Straits, Bruce C. 1998. "Occupational Sex Segregation: The Role of Personal Ties." *Journal of Vocational Behavior.* 52.2, April 191-207.

Swerdlow, Marian. 1997. "Men's Accommodations to Women's Entering a Nontraditional Occupation: A Case of Rapid Transit Operatives." In Dana Dunn, ed., *Workplace/Women's Place*, pp. 260-270. Los Angeles, Calif.: Roxbury Publishing Company.

Tausky, Curt. 1984. *Work and Society*. Itasca, Ill.: F. E. Peacock Publishers, Inc.

Thomas, Barbara. 1990. "Women's Gains in Insurance Sales: Increased Supply, Uncertain Demand." In Barbara Reskin and Patricia Roos, eds., *Job Queues, Gender Queues: Explaining Women's Inroads into Male Occupations*, pp. 183-204. Philadelphia: Temple University Press.

Thomas, Barbara, and Barbara Reskin. 1990. "A Woman's Place Is Selling Homes: Occupational Change and the Feminization of Real Estate Sales." In Barbara Reskin, and Patricia Roos, eds., *Job Queues, Gender Queues: Explaining Women's Inroads into Male Occupations*. Pp. 205-223. Philadelphia: Temple University Press.

Thomas, Paulette. 1999. "Closing the Gender Gap." *Wall Street Journal*. May 24: R12.

Thompson, William E. 1991. "Handling the Stigma of Handling The Dead: Morticians and Funeral Directors." *Deviant Behavior* 124: 403-429.

Throckmorton, Robert. 1973. "Boundary Roles and Occupational Integration: An Examination of the Automobile Salesman." Ph.D. dissertation, University of Washington.

Vaughan, Diane. 1983. *Controlling Unlawful Organizational Behavior: Social Structure and Corporate Misconduct*. Chicago: University of Chicago Press.

Walshok, Mary. 1981. *Blue-Collar Women: Pioneers on the Male Frontier*. Garden City, N.Y.: Anchor Doubleday.

Weiss, Robert S. 1990. *Staying the Course: The Emotional and Social Lives of Men Who Do Well at Work*. New York: Free Press.

West, Candace, and Sarah Fenstermaker. 1995. "Doing Difference." *Gender and Society*. 9 (1) (February): 8-37.

West, Candace and Don H. Zimmerman. 1987. "Doing Gender." *Gender and Society*. 1 (2) (June): 125-151.

Whyte, William Foote. 1961. *Men at Work*. Homewood, Ill.: Dorsey Press.

Wolf, Naomi. 1993. *Fire with Fire: The New Female Power and How to Use It*. New York: Fawcett Columbine.

Yount, Kristen R. 1991. "Ladies, Flirts, and Tomboys; Strategies for Managing Sexual Harassment in an Underground Coal Mine." *Journal of Contemporary Ethnography* 19 (4): 396-422.

Zimmer, Lynn. 1987. "How Women Reshape the Prison Guard Role." *Gender and Society*. 1 (4): 415-431.

Index

ABOUT THE AUTHOR

Helene M. Lawson is associate professor of sociology and director of the Gender Studies Program at the University of Pittsburgh, Bradford. She has published articles on hair workers and on gender equality in working class families. Her current research centers on conservation officers' interactions with hunted animals.

DATE